BERKSHIRE
IN PHOTOGRAPHS

JIM HELLIER

AMBERLEY

First published 2020

Amberley Publishing
The Hill, Stroud
Gloucestershire, GL5 4EP

www.amberley-books.com

Copyright © Jim Hellier, 2020

The right of Jim Hellier to be identified as the Author of this work has been
asserted in accordance with the Copyrights, Designs and Patents Act 1988.

ISBN 978 1 4456 9430 6 (print)
ISBN 978 1 4456 9431 3 (ebook)

British Library Cataloguing in Publication Data.
A catalogue record for this book is available from the British Library.

Typesetting by Aura Technology and Software Services, India.
Printed in the UK.

ACKNOWLEDGEMENTS

I would like to thank the staff at Amberley Publishing and all my friends and family who helped me produce this book.

ABOUT THE AUTHOR

Jim took his first transparencies on a visit to Windsor Castle at the age of eleven with a Kodak Instamatic. This led to a lifelong passion for photography, although Jim did not go professional until later in life. After working as a building surveyor for one of the largest water companies in the UK, he took the opportunity to take an early retirement, which enabled him to take up photography full time.

He has always primarily been a landscape and travel photographer, though he has also worked with well-known fashion and fine art photographer Jerry Mason. These collaborations included travels to the Bahamas, Miami and the south of France – one of Jim's favourite locations.

Jim's landscape and travel work has been published in magazines such as *This England*, *Canal and Riverboat* and *French Life*. Some of the calendar companies that use Jim's images include Brunel Publishing, Rose of Colchester, Bemrose and Carousel Calendars.

Jim has also written e-book guides to photography and runs landscape photography courses.

INTRODUCTION

Within this book you will find many wonderful landscape images that I have captured with my camera while on my travels around the county of Berkshire. I have lived in this area for the last forty-plus years and I am still finding places of outstanding natural beauty that take my breath away. This is because Berkshire is an ancient county with sites that go back to Neolithic times. One such town is Thatcham, which is one of the oldest continuously inhabited areas in the United Kingdom.

Many towns were established along the banks of the River Thames, which was a major trading route for the county. The completion of the Kennet & Avon Canal in 1810 opened cargo travel between London and Bristol, bringing new life and business to the area. Then, with the arrival of the Great Western Railway, industry started to boom. Today you can see that the county is home to many companies within diverse sectors of industry.

Berkshire received the title of 'Royal County' from Elizabeth II in 1957 due to the presence of Windsor Castle. The royal family have been in residence there in some guise since it was built by William the Conqueror. The first recorded monarch to live there was Henry I – William's fourth son.

Scattered around the county you will find evidence of a rich history, from Windsor Castle to Donnington Castle – the latter now in ruins. There are burial mounds known as long barrows that can still be found on the Berkshire Downs, and just on the county border you will find the small village of Silchester, which was once a Roman settlement, with its city walls and amphitheatre still visible today.

As a photographer I have found that living in such a county fuels my passion for landscape photography. Quite often I will find myself returning to places to capture multiple angles and different lighting to make sure that the beauty I see before my eyes is truly translated to the printed form. In this book I hope to show you many of the wonderful and unique features that have inspired me over the years, and caused me to travel the length and breadth of Berkshire, capturing famous sites such as Windsor Castle, Eton College – where the princes William and Harry attended school – and, of course, the magnificent River Thames.

In recent times Greenham Common has once again become a site of interest with the filming of the latest Star Wars films taking place there, adding to its already rich history and proving that it really is all about location, location, location.

I hope that you enjoy this compilation of some of my favourite landscape photographs of Berkshire with its diversity of urban and country areas, beautiful down lands, and sparkling rivers.

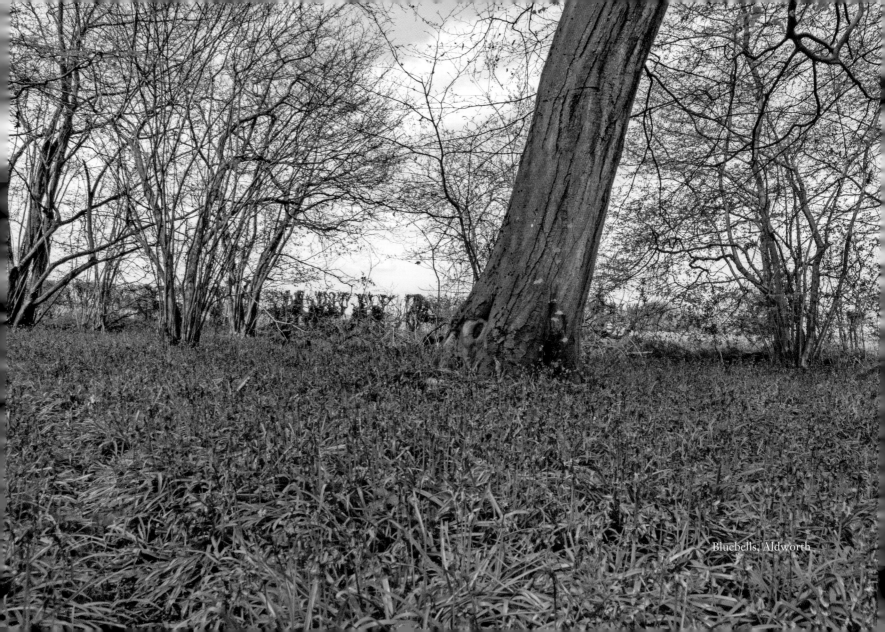

Bluebells, Aldworth

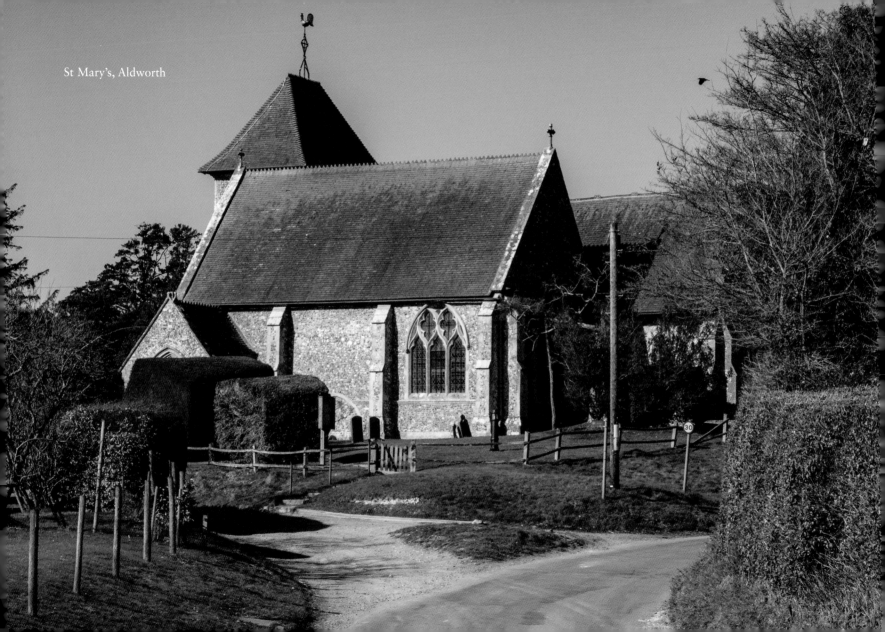
St Mary's, Aldworth

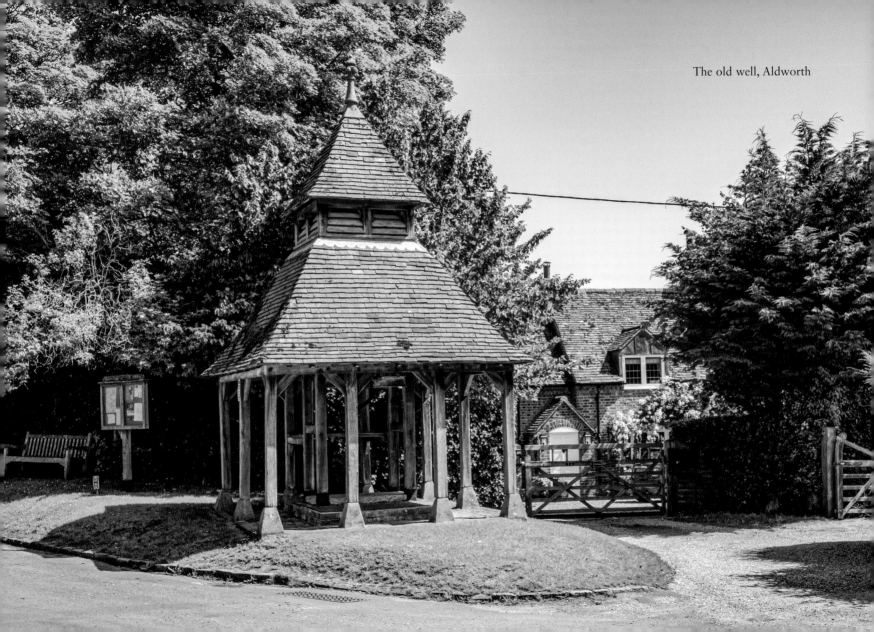

The old well, Aldworth

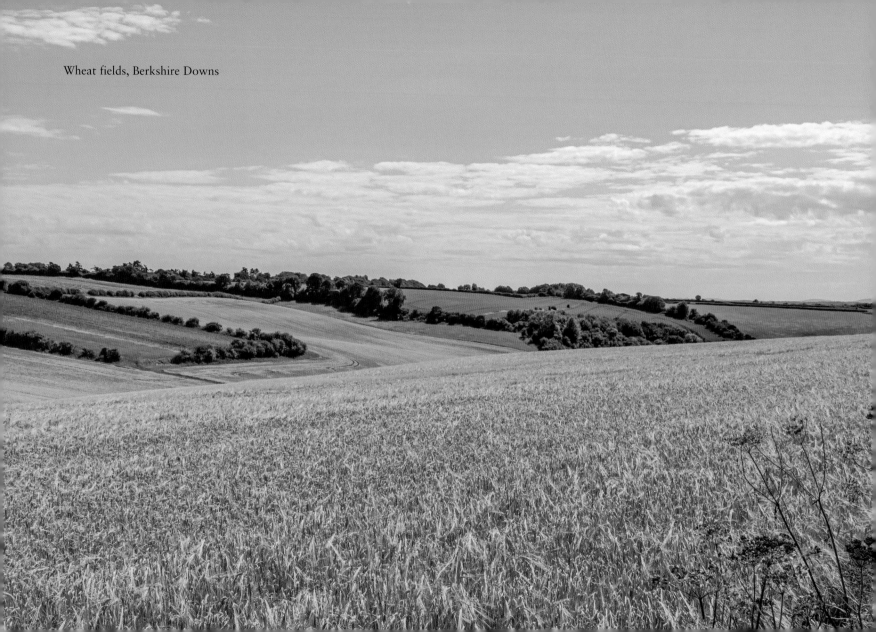

Wheat fields, Berkshire Downs

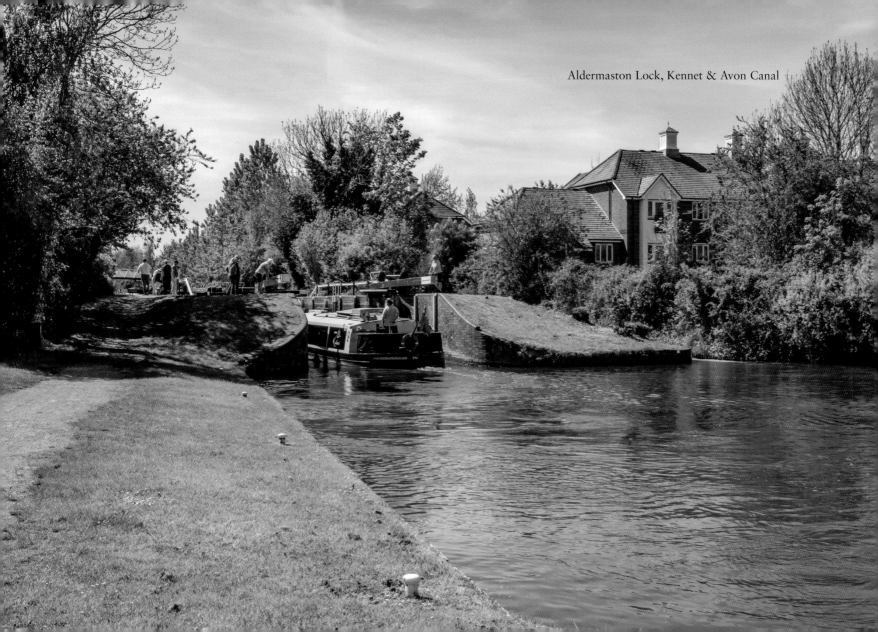

Aldermaston Lock, Kennet & Avon Canal

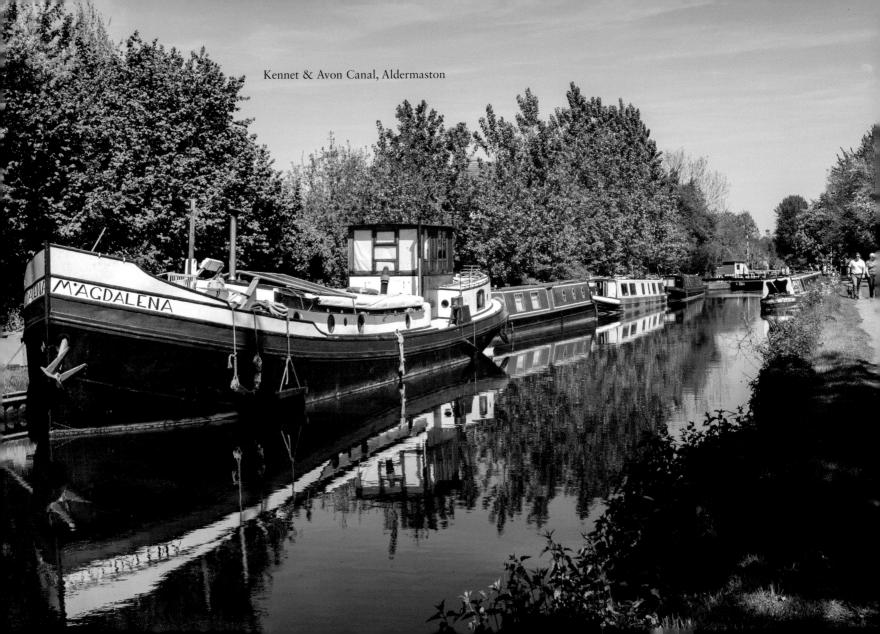

Kennet & Avon Canal, Aldermaston

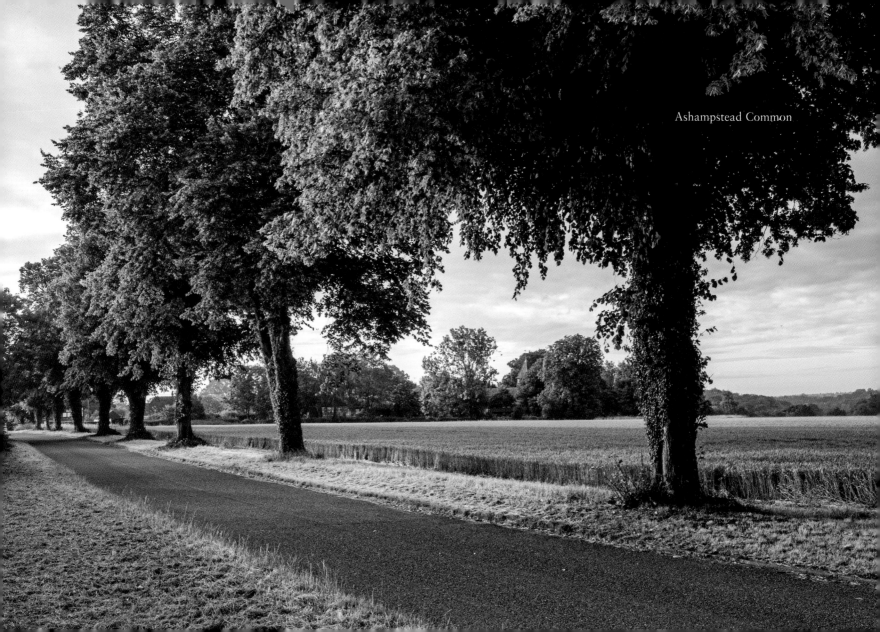

Ashampstead Common

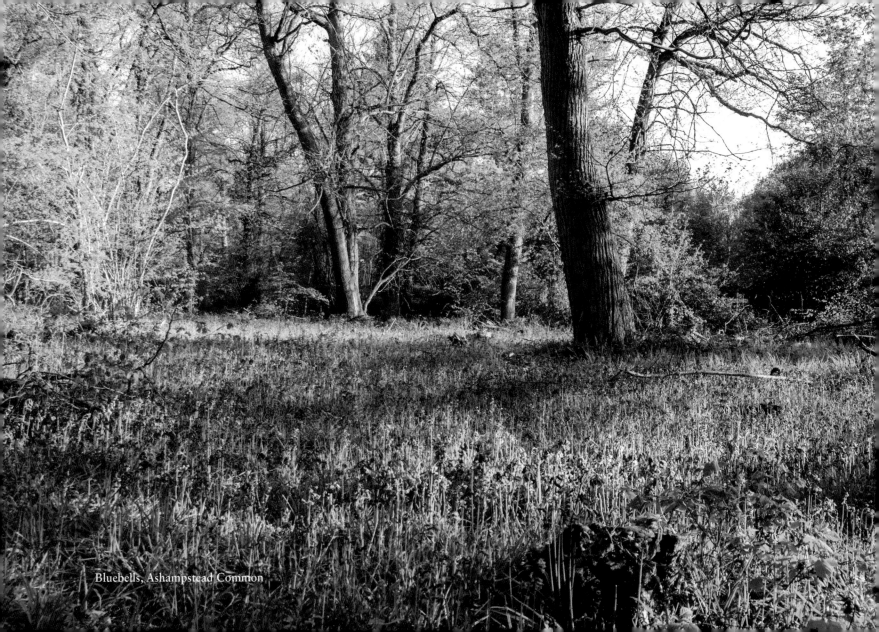
Bluebells, Ashampstead Common

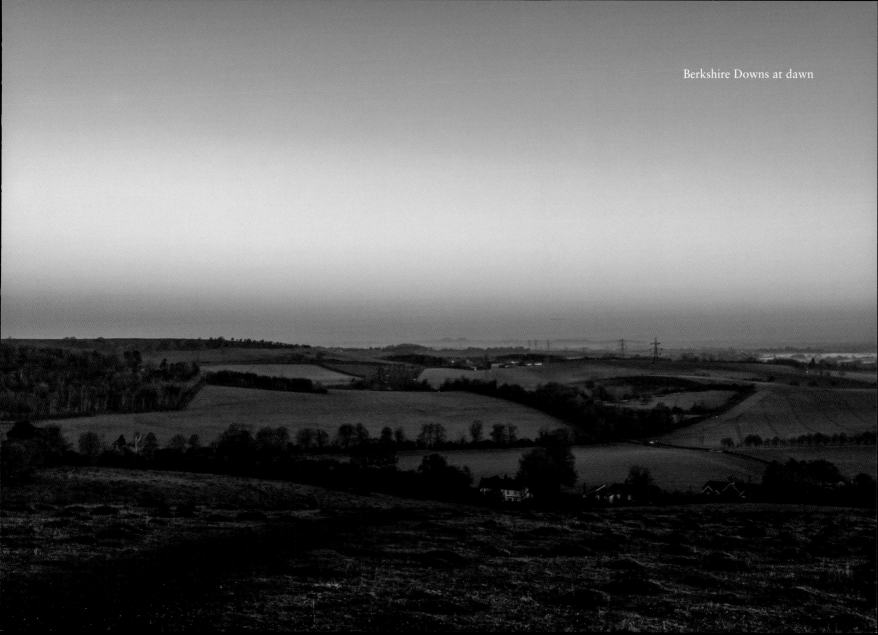

Berkshire Downs at dawn

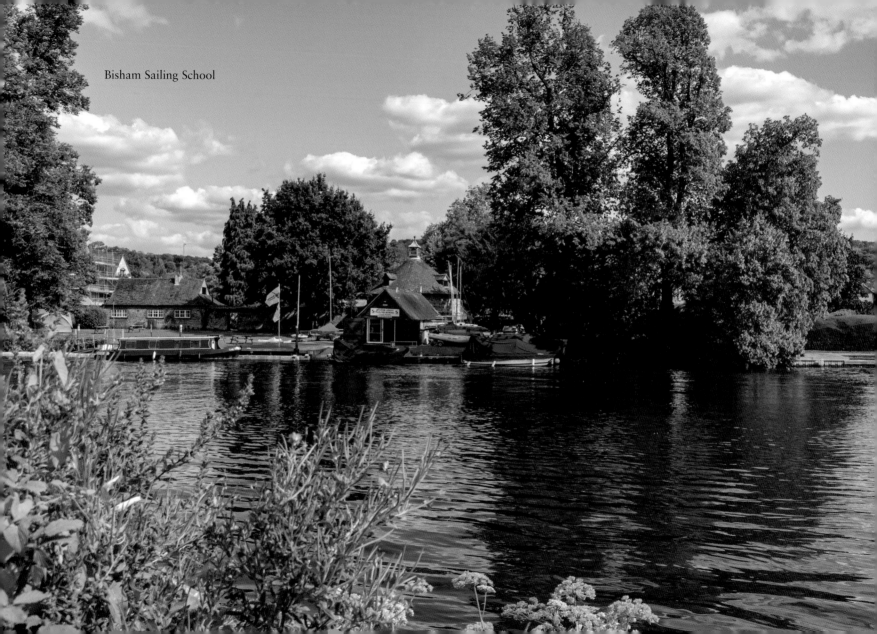

Bisham Sailing School

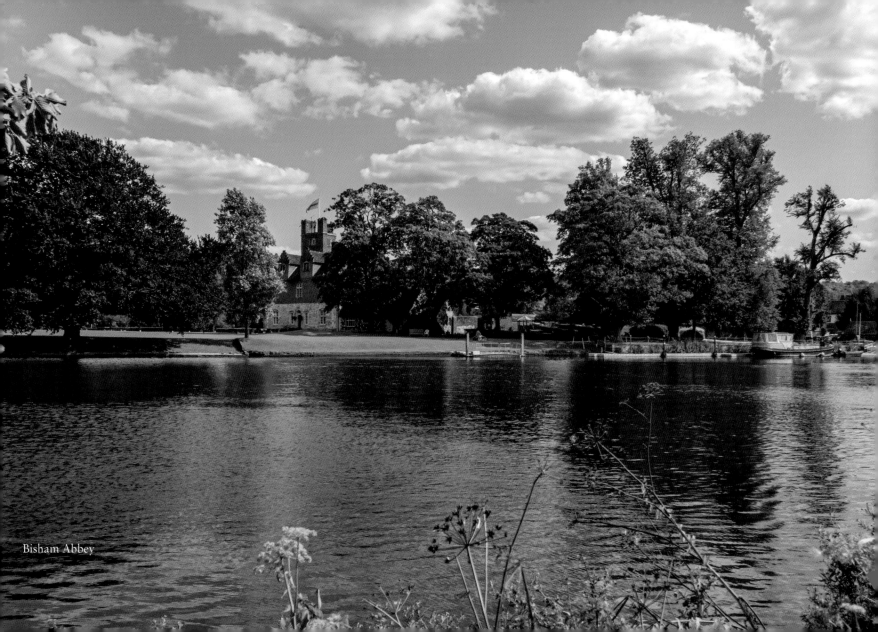

Bisham Abbey

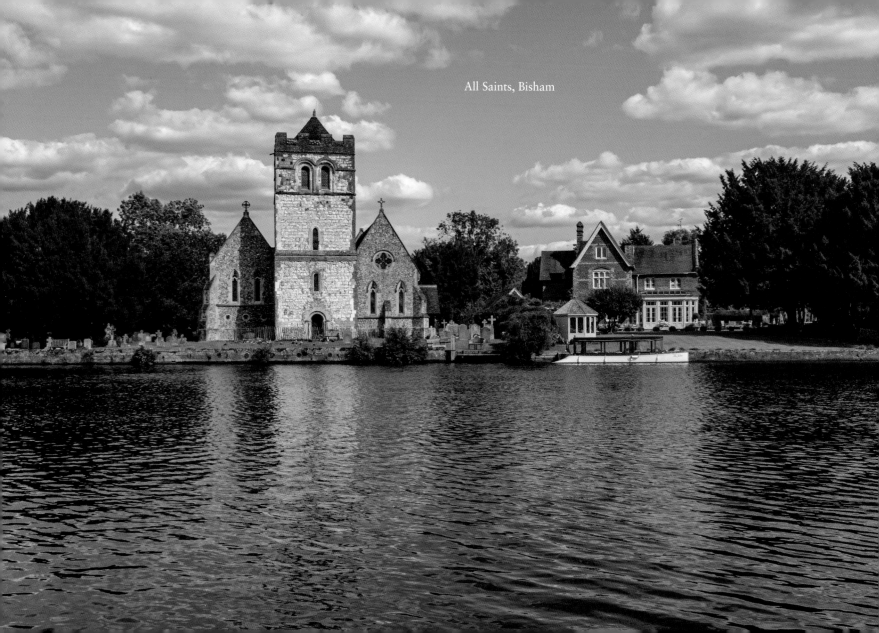
All Saints, Bisham

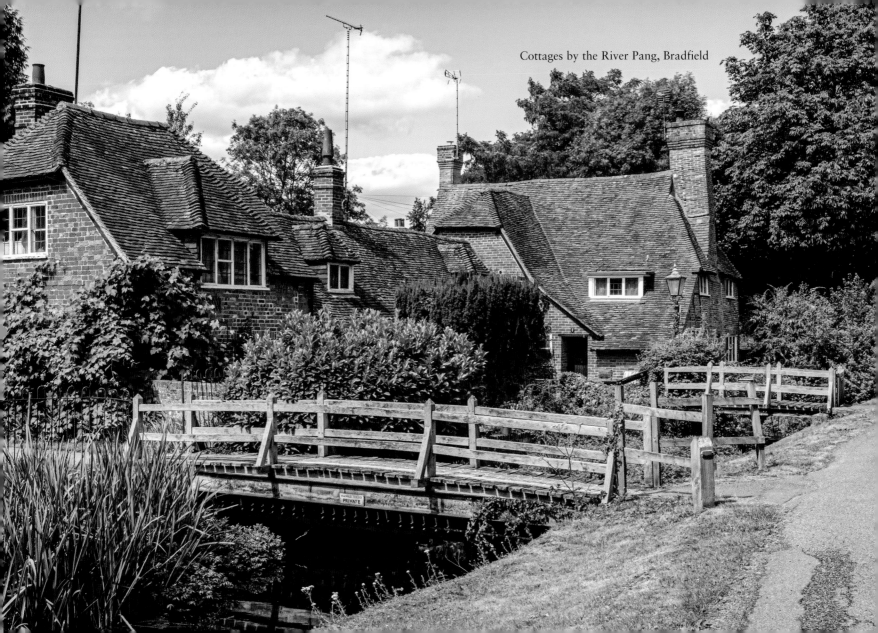

Cottages by the River Pang, Bradfield

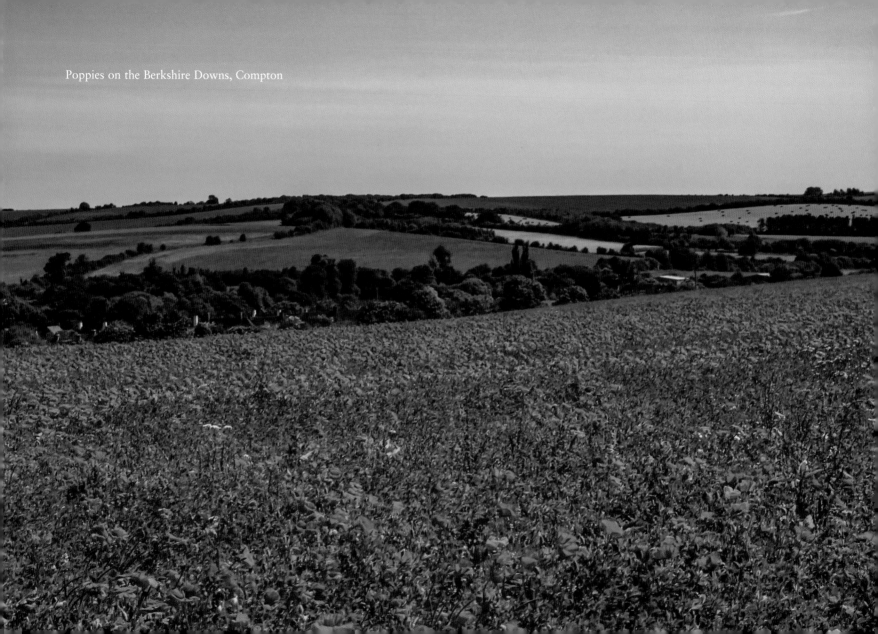

Poppies on the Berkshire Downs, Compton

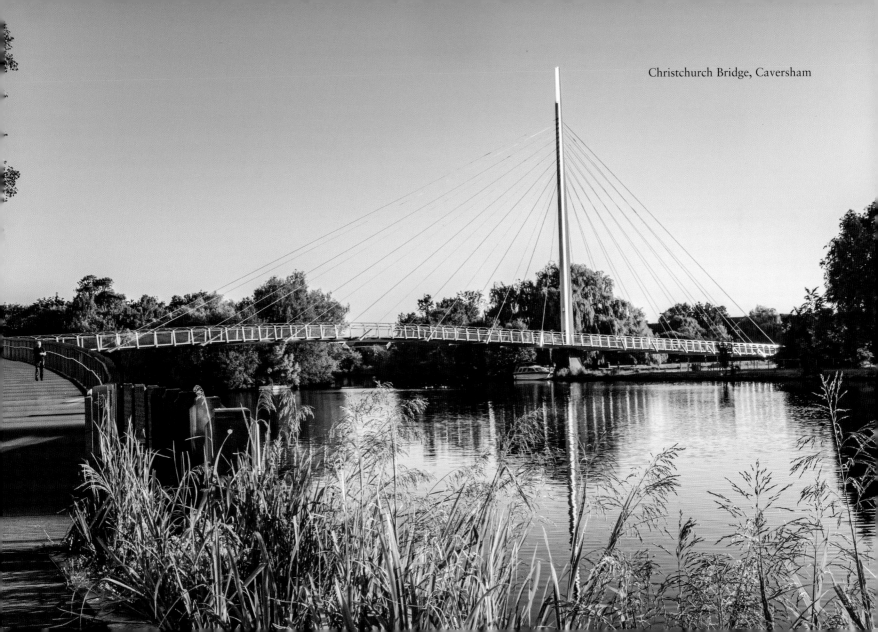

Christchurch Bridge, Caversham

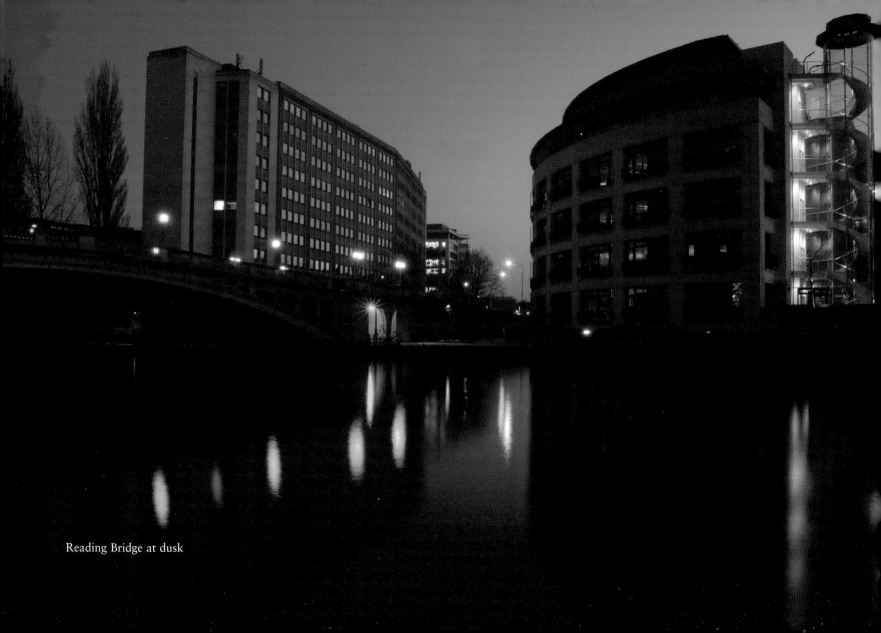
Reading Bridge at dusk

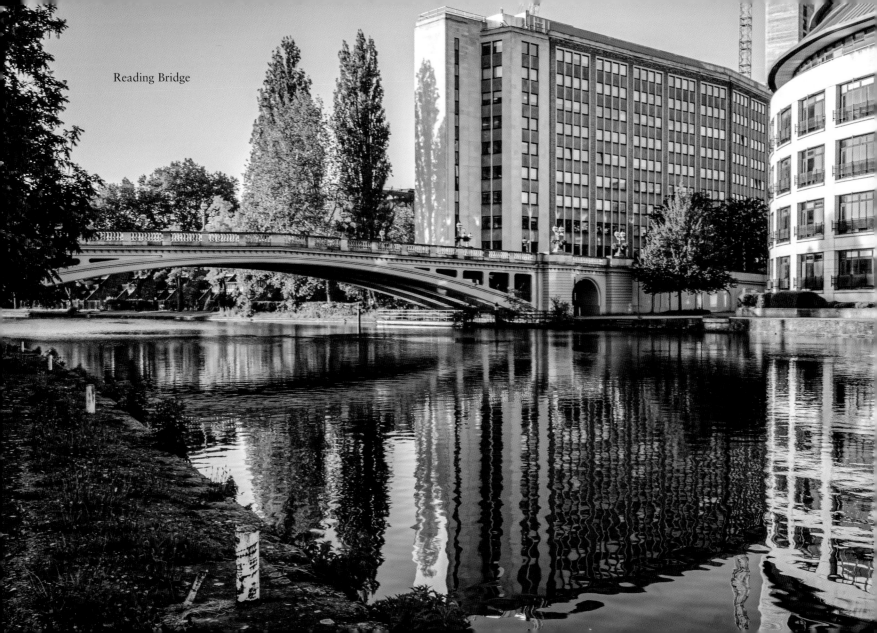

Reading Bridge

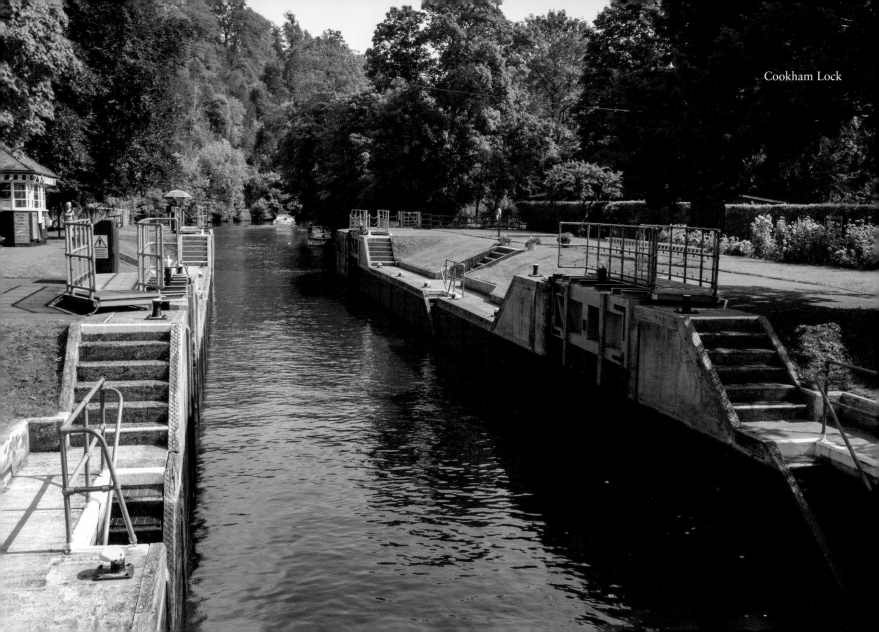

Cookham Lock

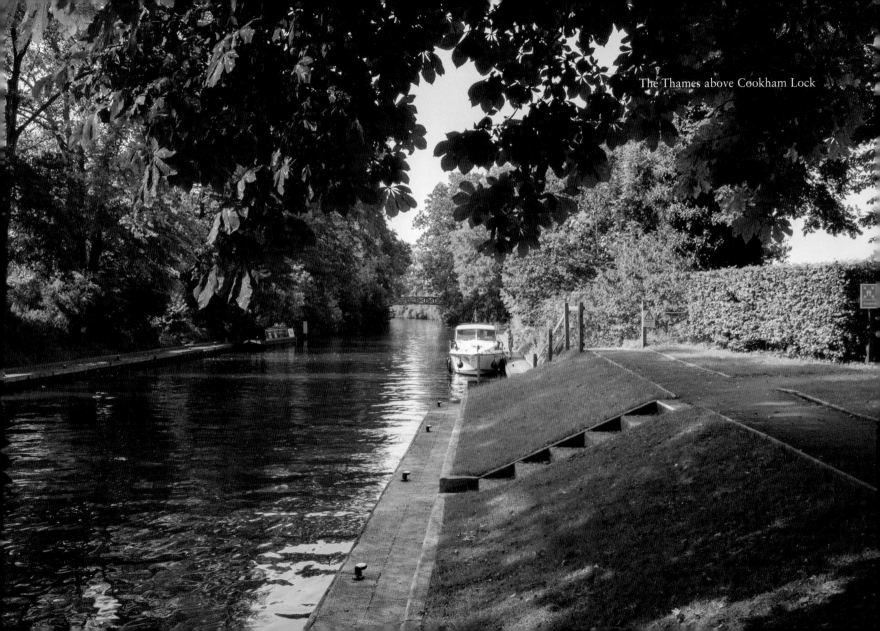
The Thames above Cookham Lock

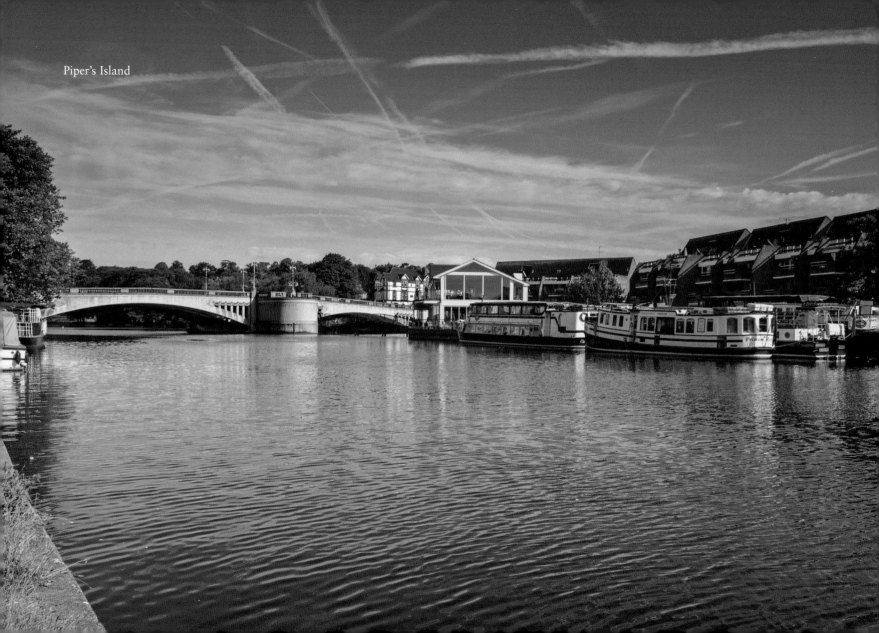
Piper's Island

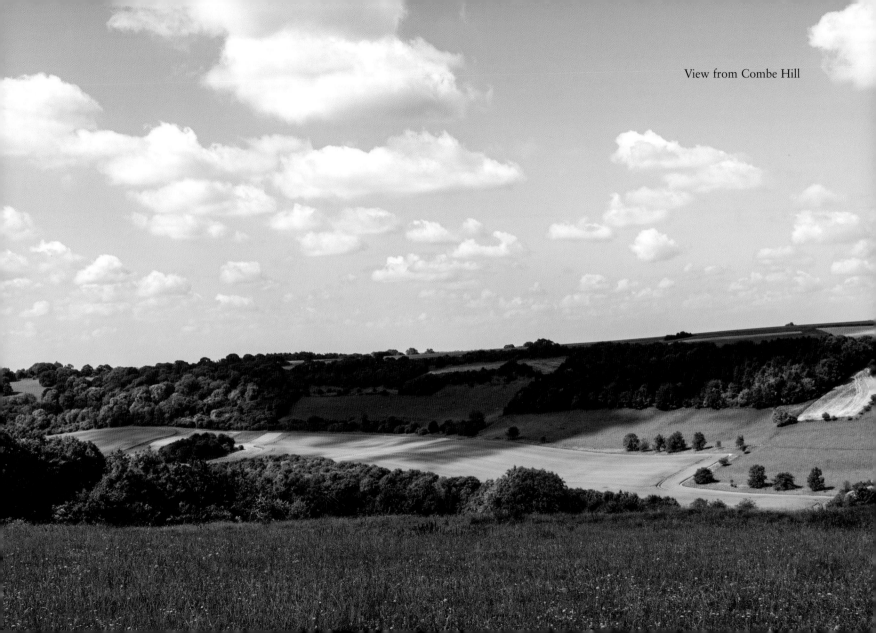
View from Combe Hill

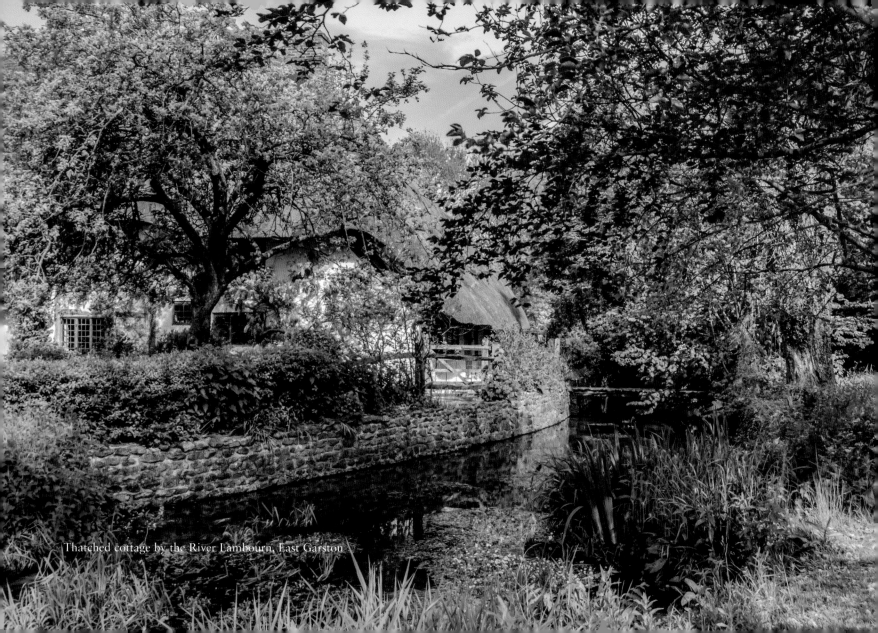

Thatched cottage by the River Lambourn, East Garston

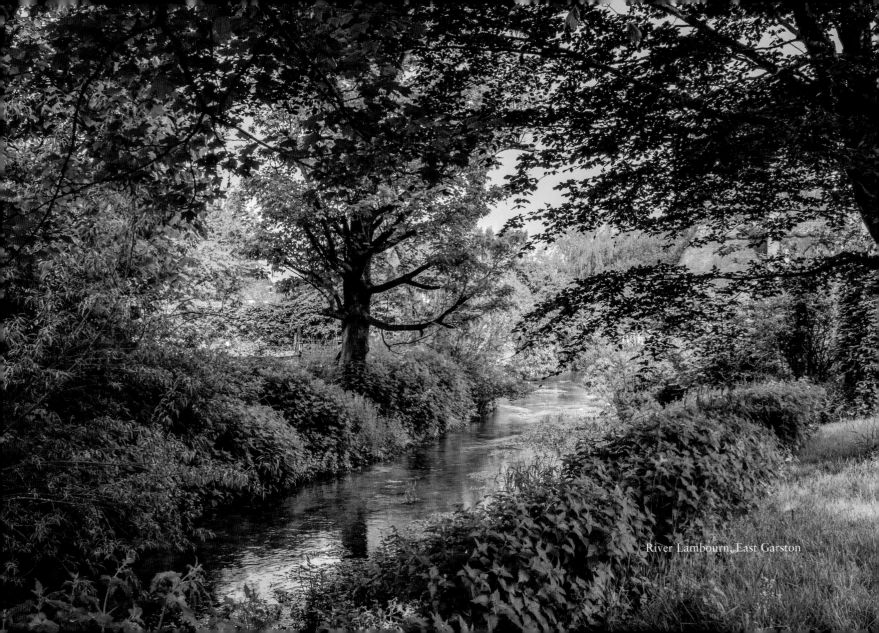
River Lambourn, East Garston

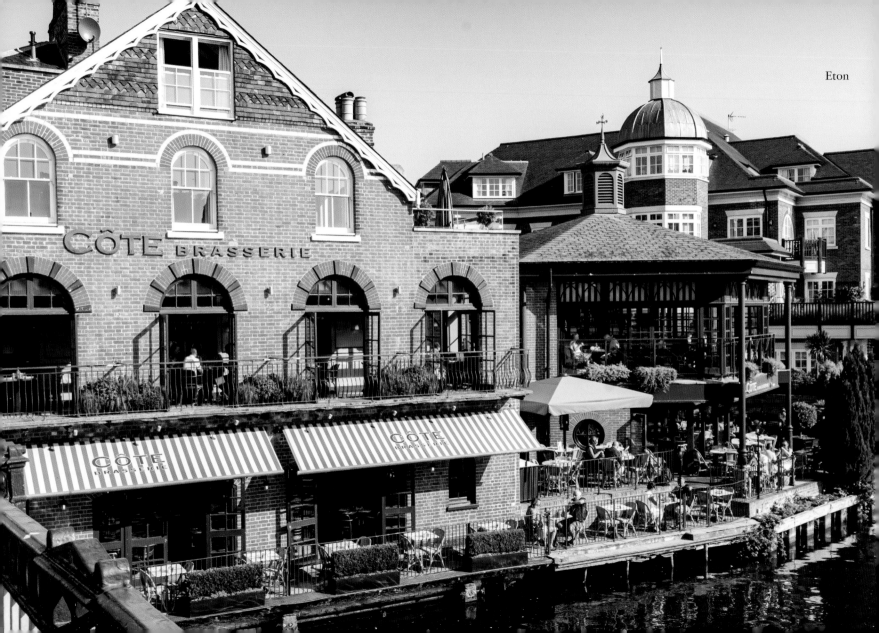

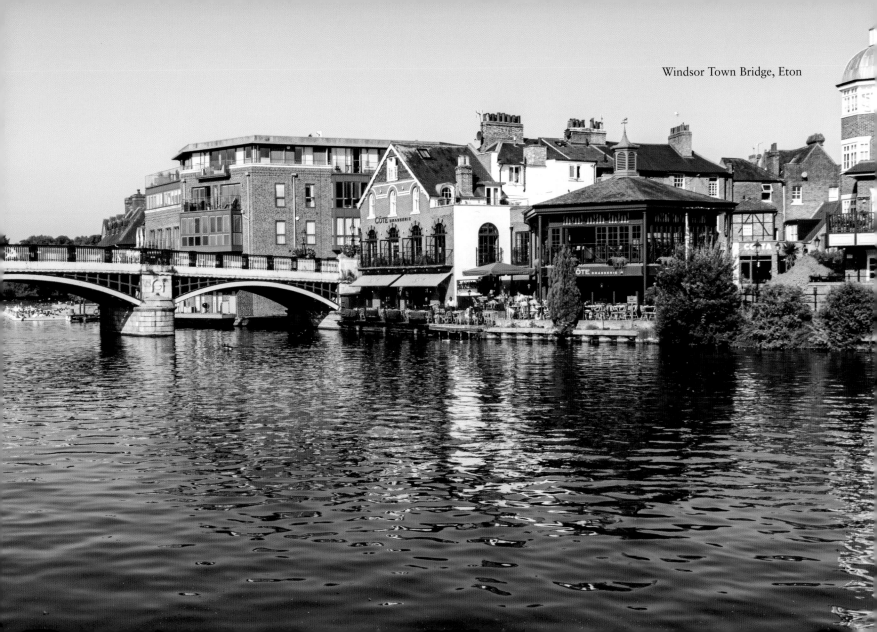

Windsor Town Bridge, Eton

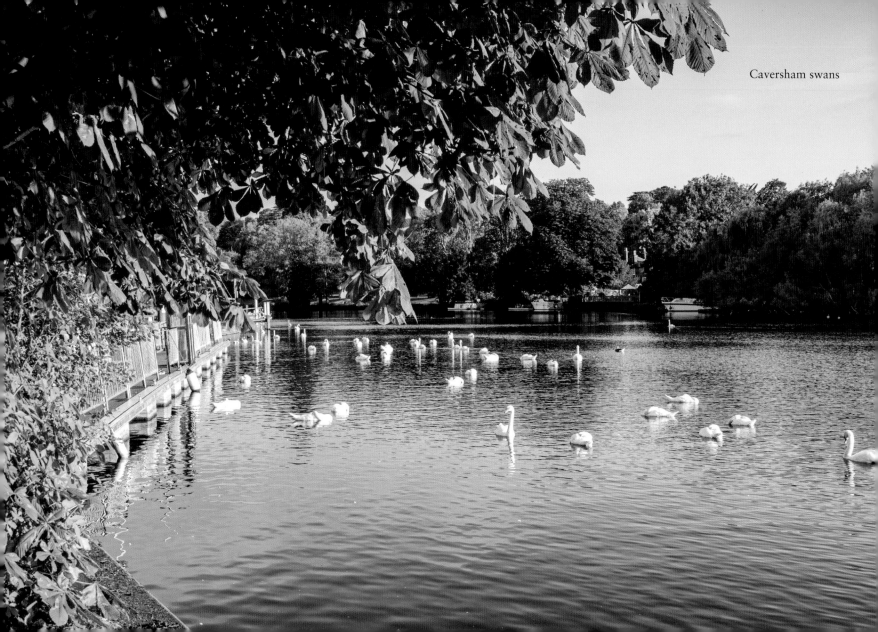

Caversham swans

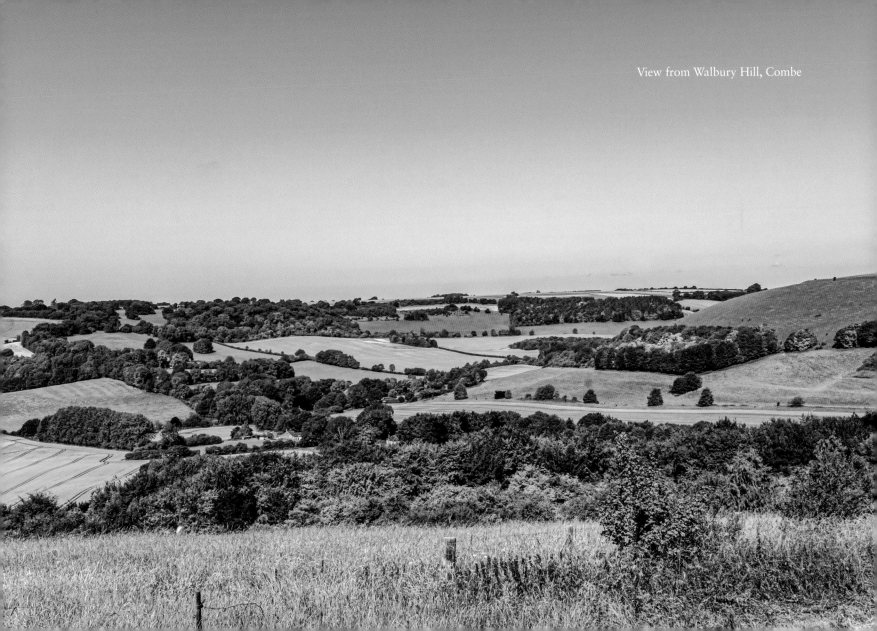
View from Walbury Hill, Combe

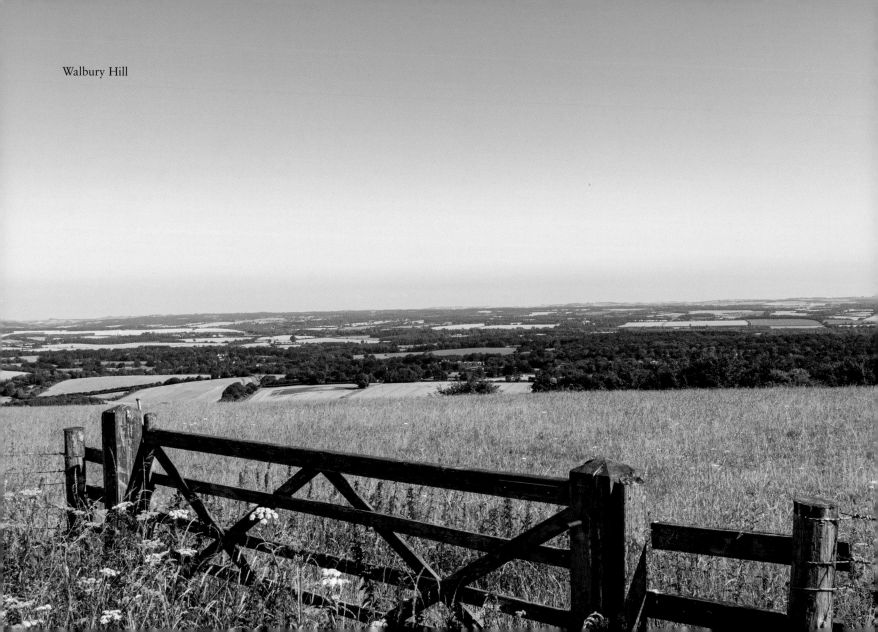

Walbury Hill

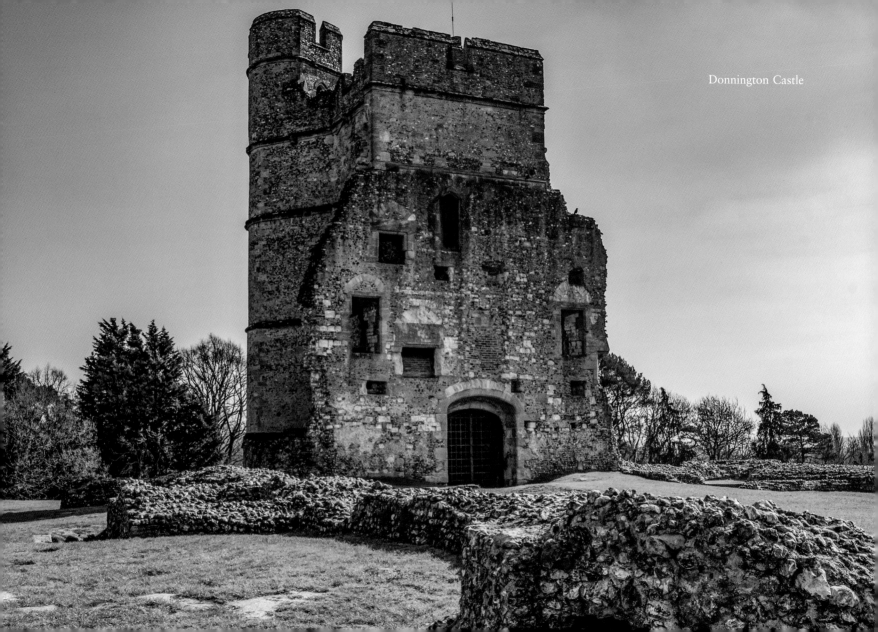

Donnington Castle

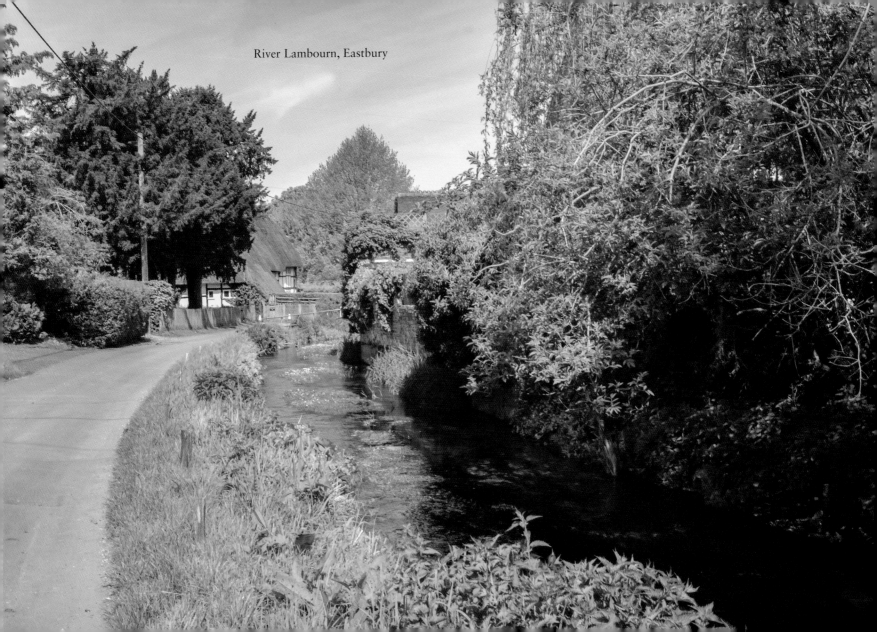

River Lambourn, Eastbury

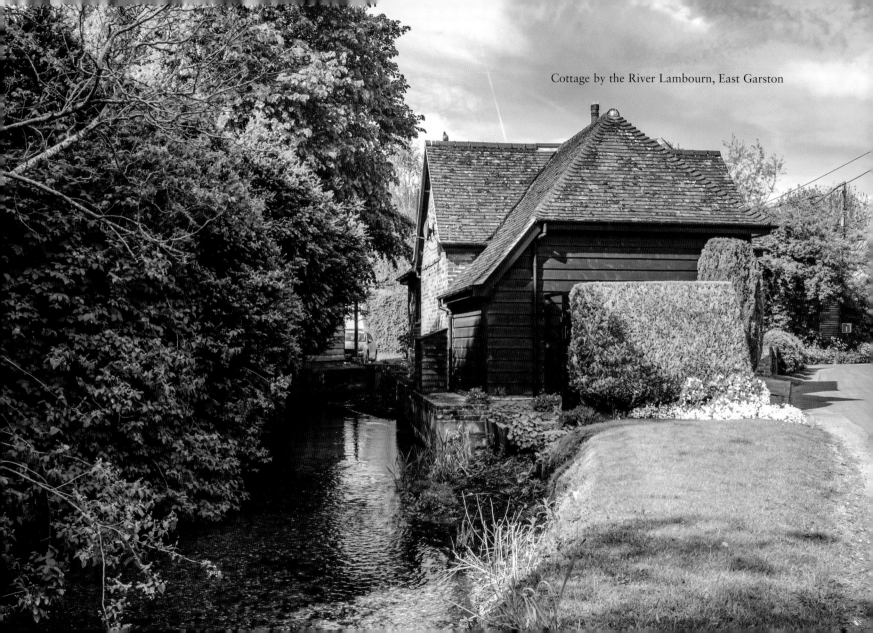

Cottage by the River Lambourn, East Garston

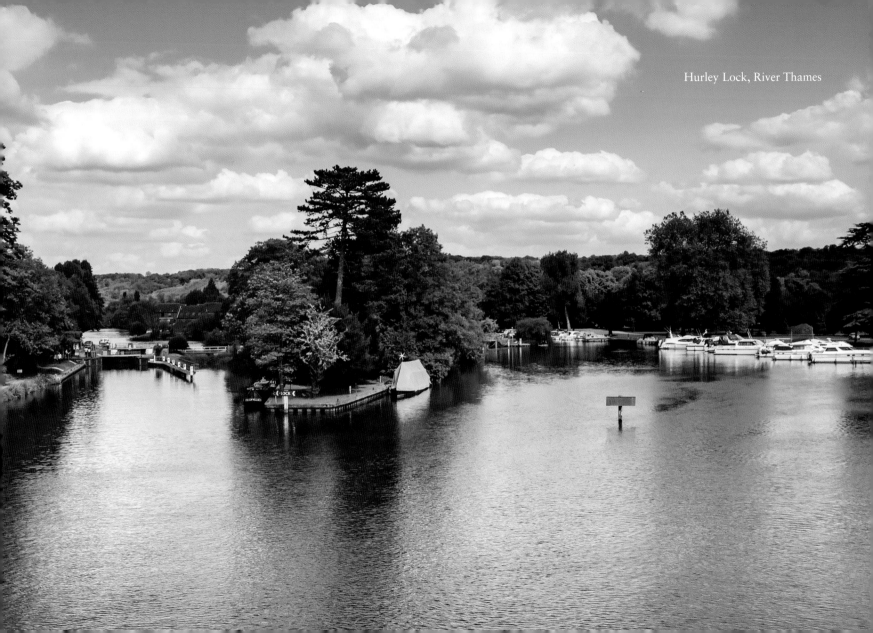

Hurley Lock, River Thames

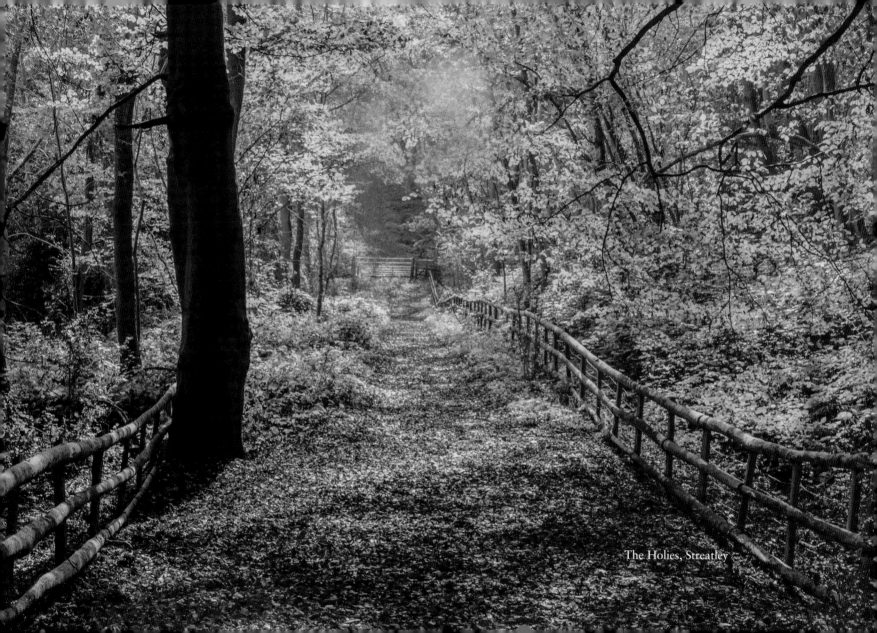

The Holies, Streatley

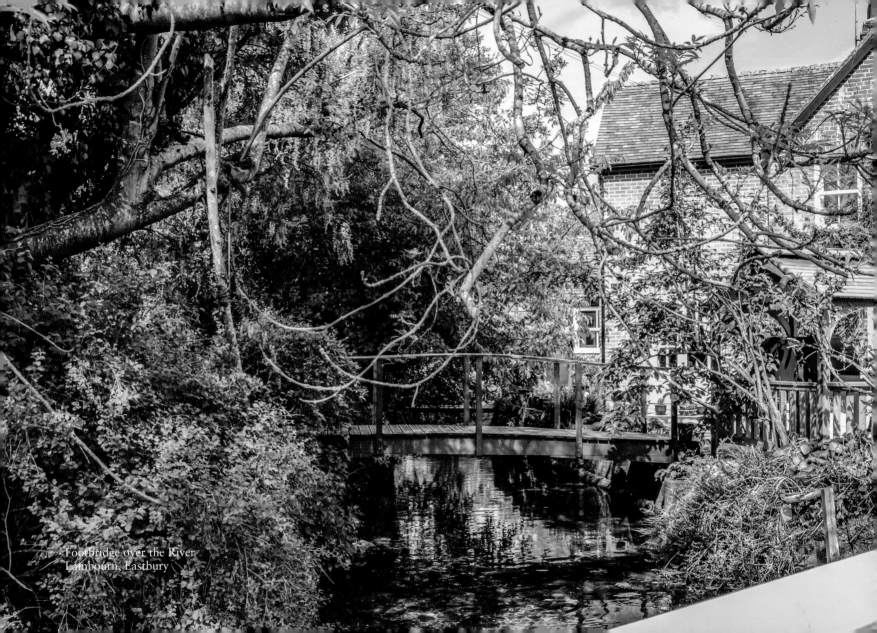

Footbridge over the River
Lambourn, Eastbury

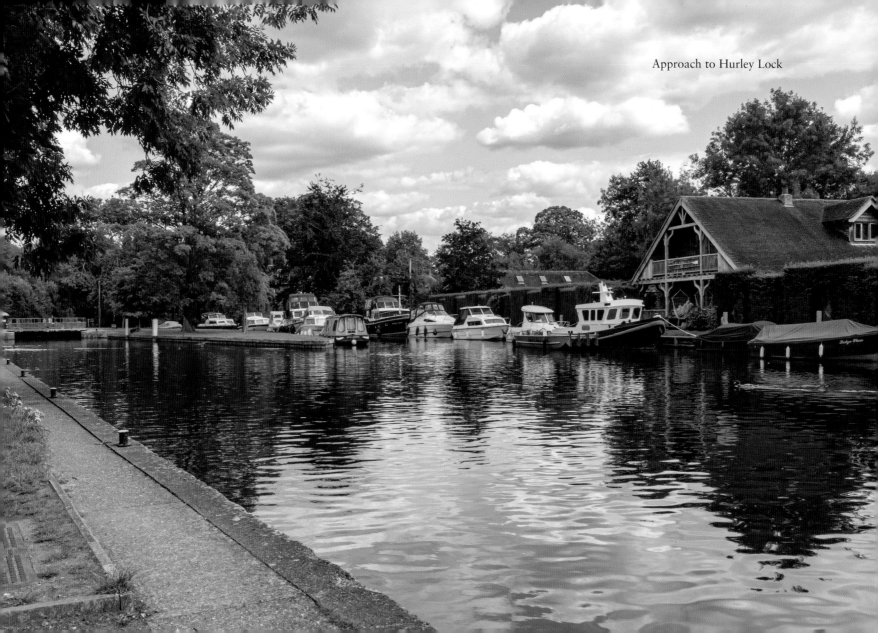

Approach to Hurley Lock

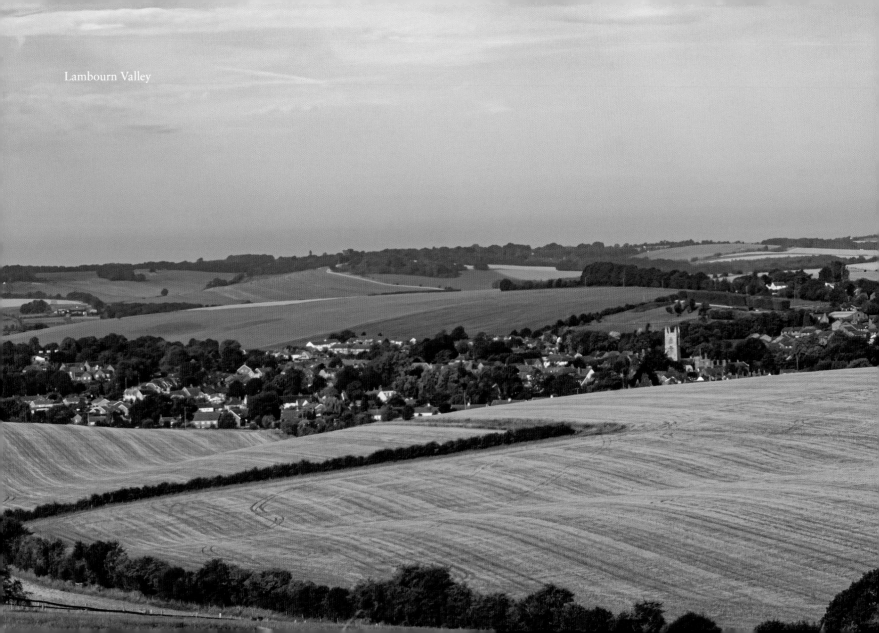

Lambourn Valley

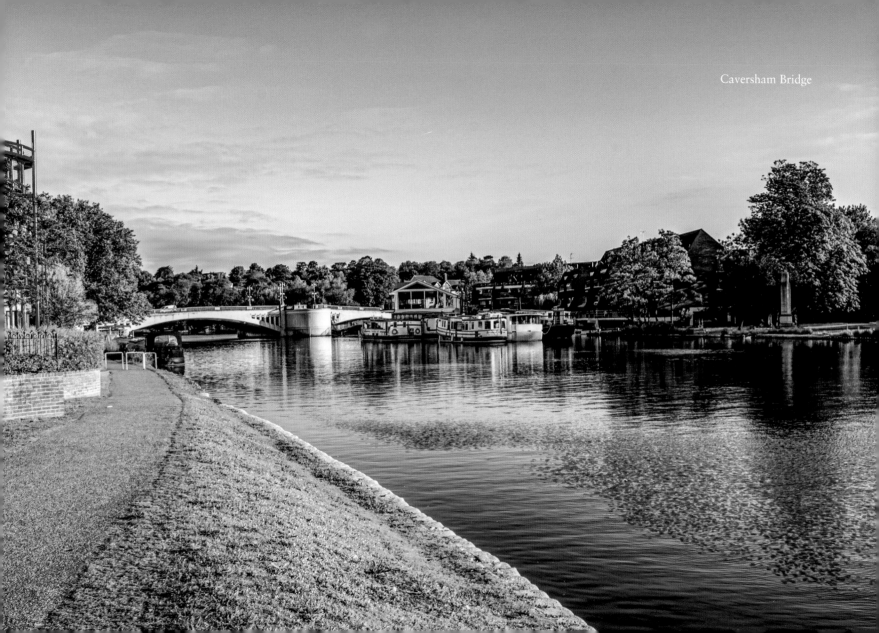
Caversham Bridge

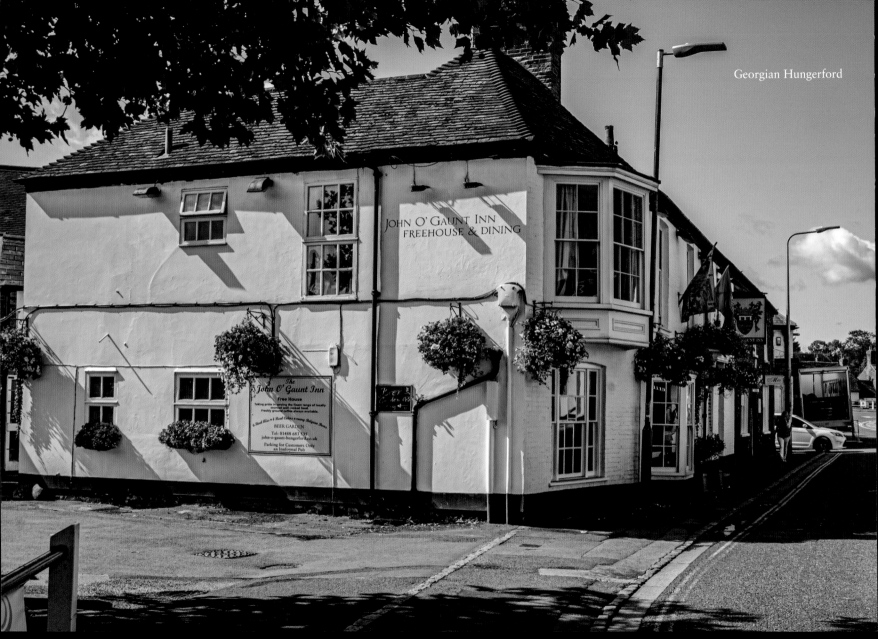

Georgian Hungerford

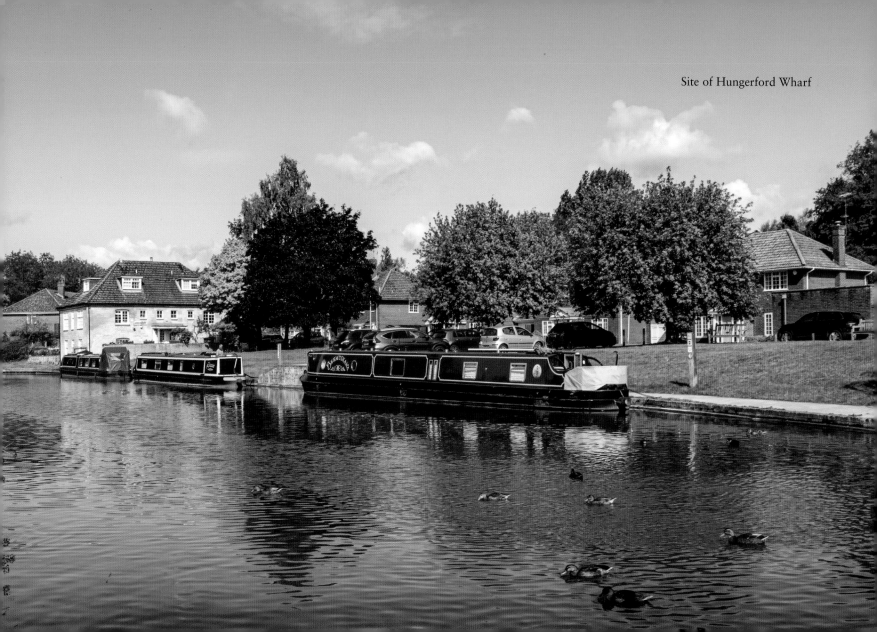

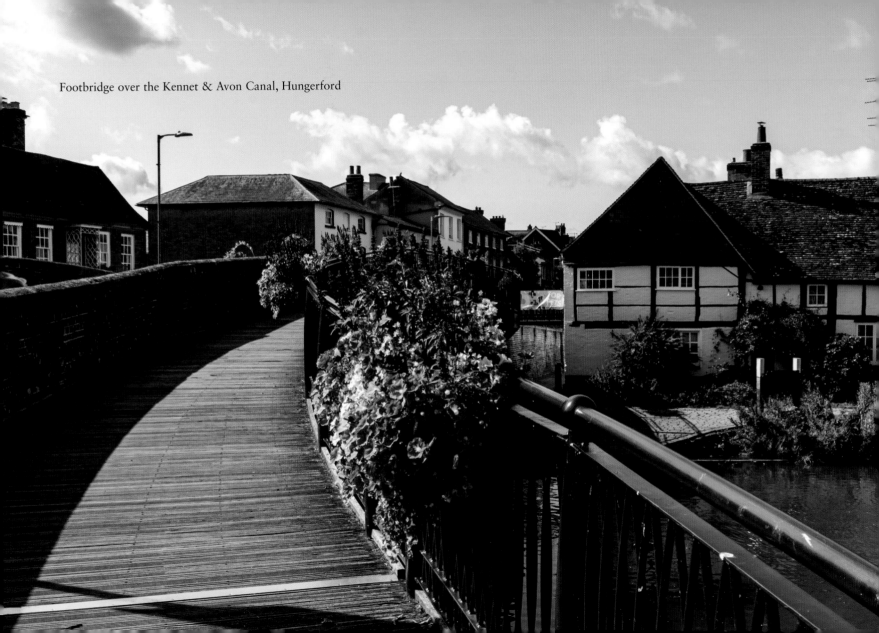
Footbridge over the Kennet & Avon Canal, Hungerford

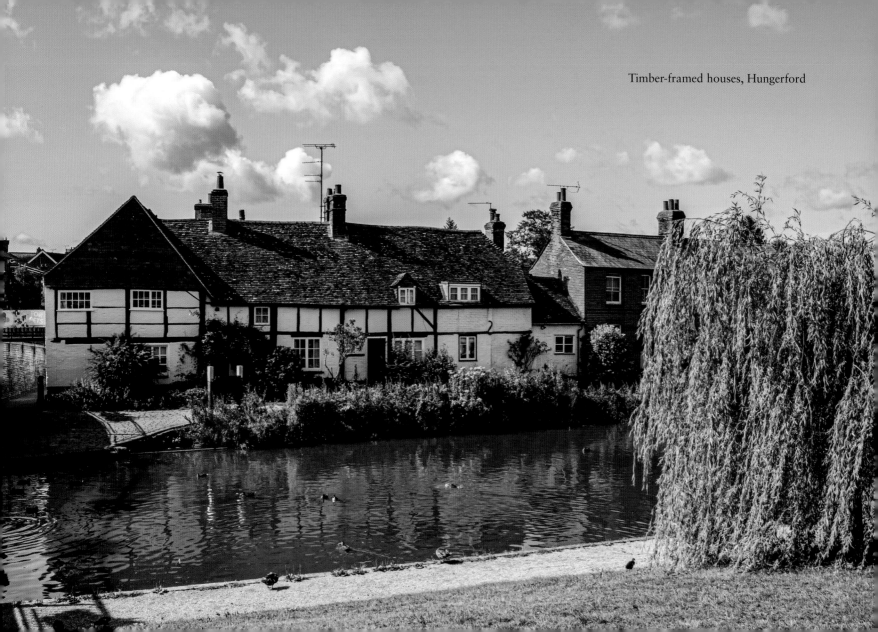

Timber-framed houses, Hungerford

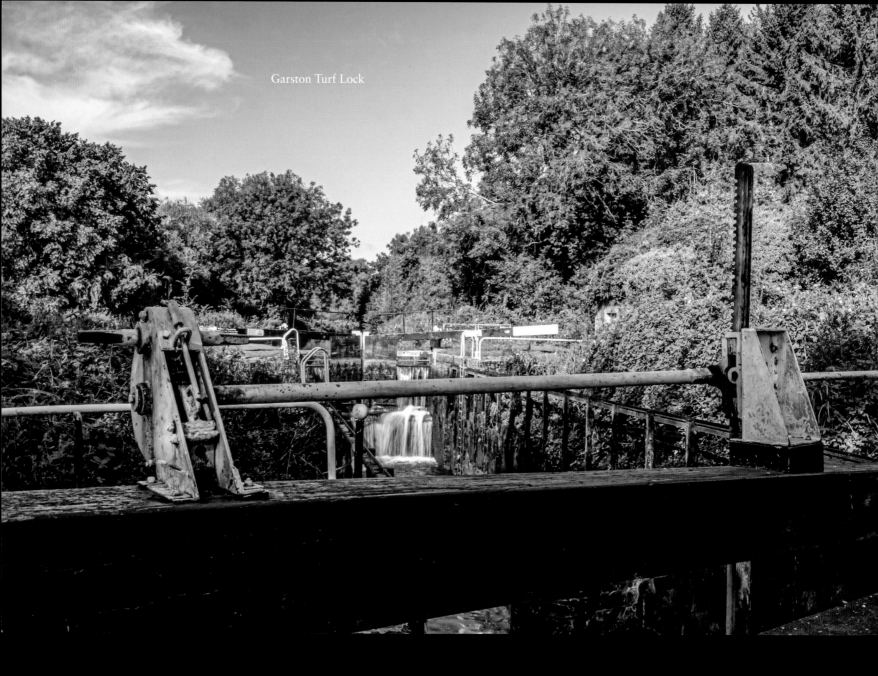

Garston Turf Lock

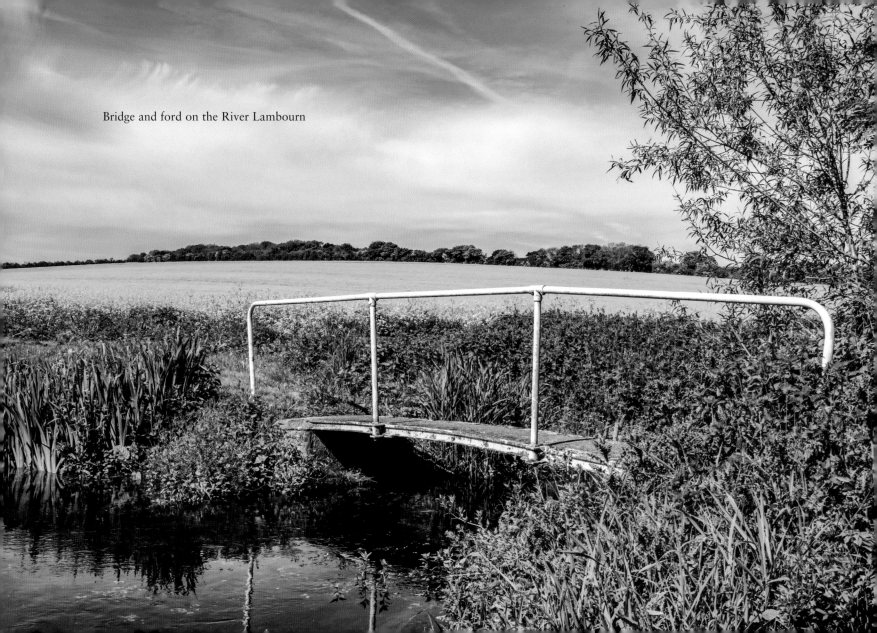

Bridge and ford on the River Lambourn

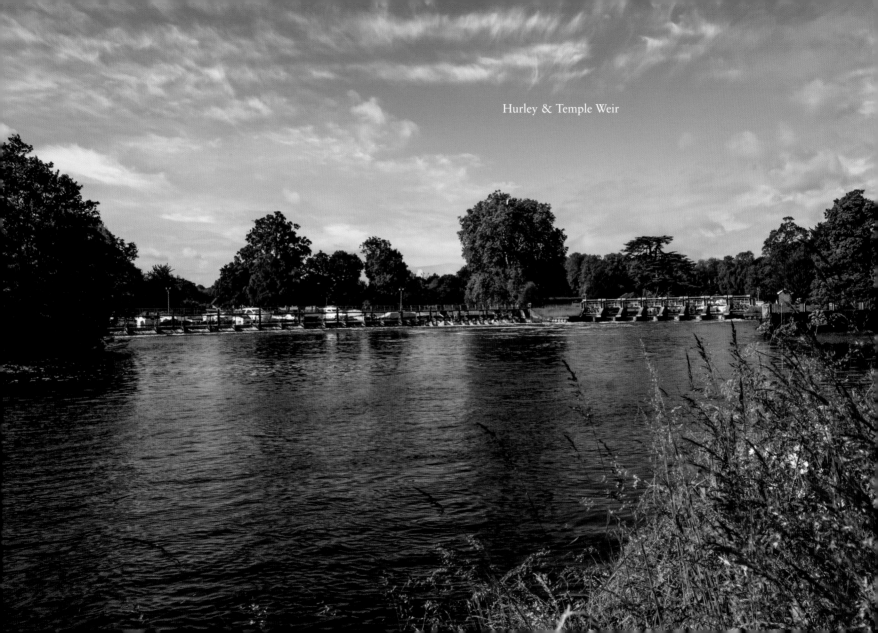
Hurley & Temple Weir

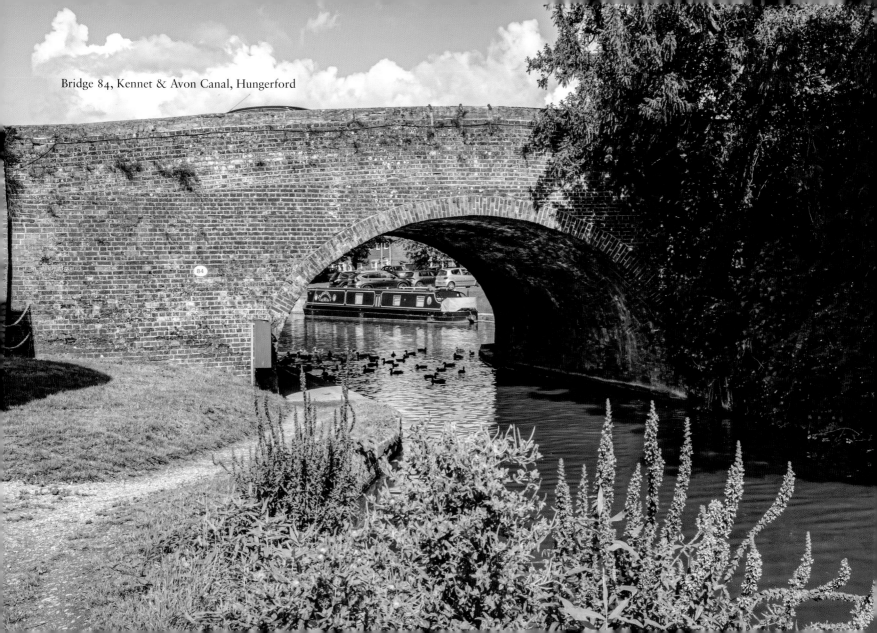

Bridge 84, Kennet & Avon Canal, Hungerford

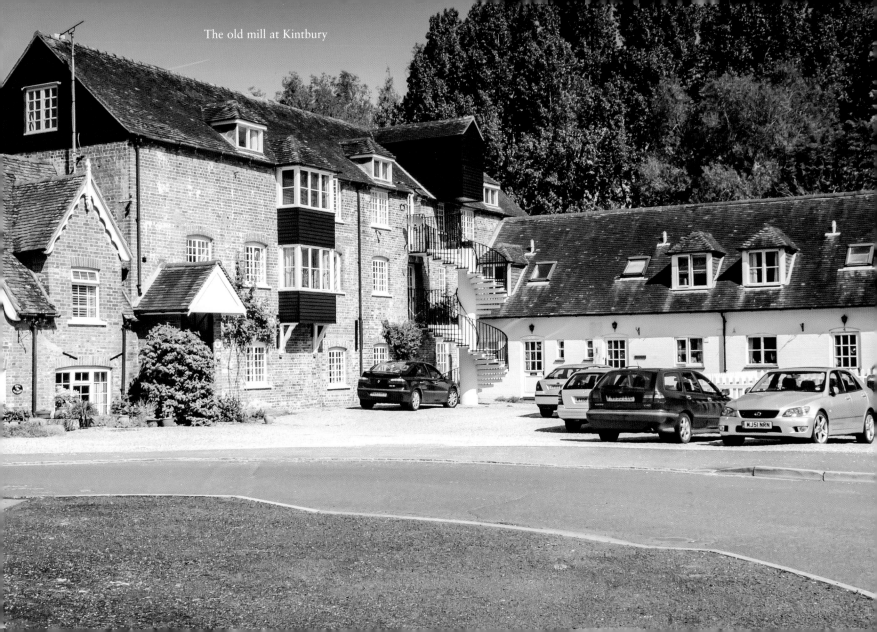

The old mill at Kintbury

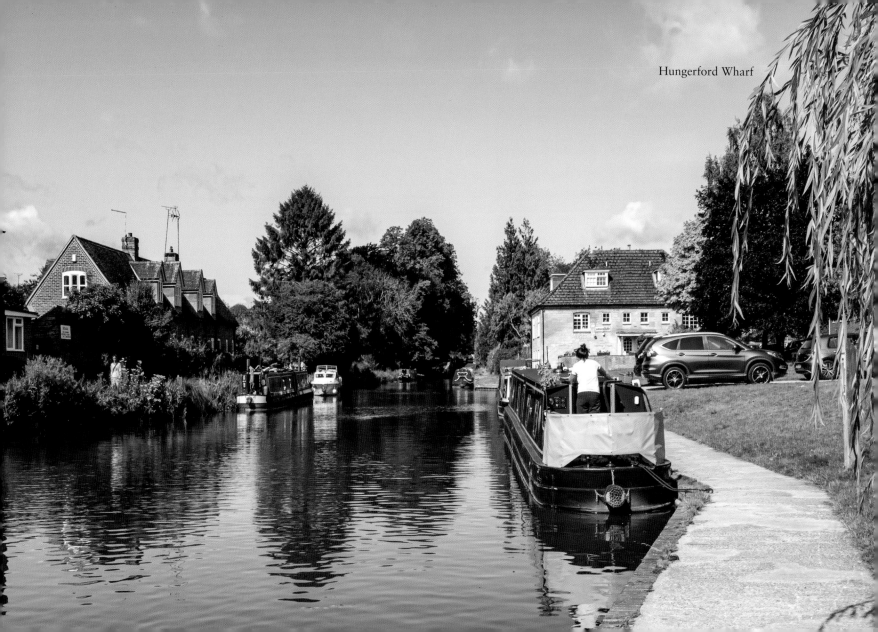

Hungerford Wharf

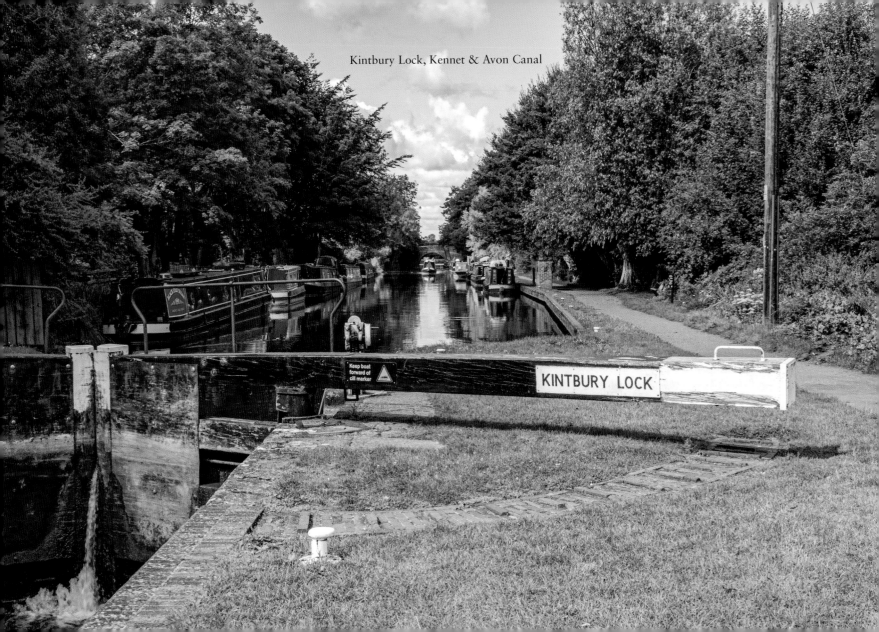

Kintbury Lock, Kennet & Avon Canal

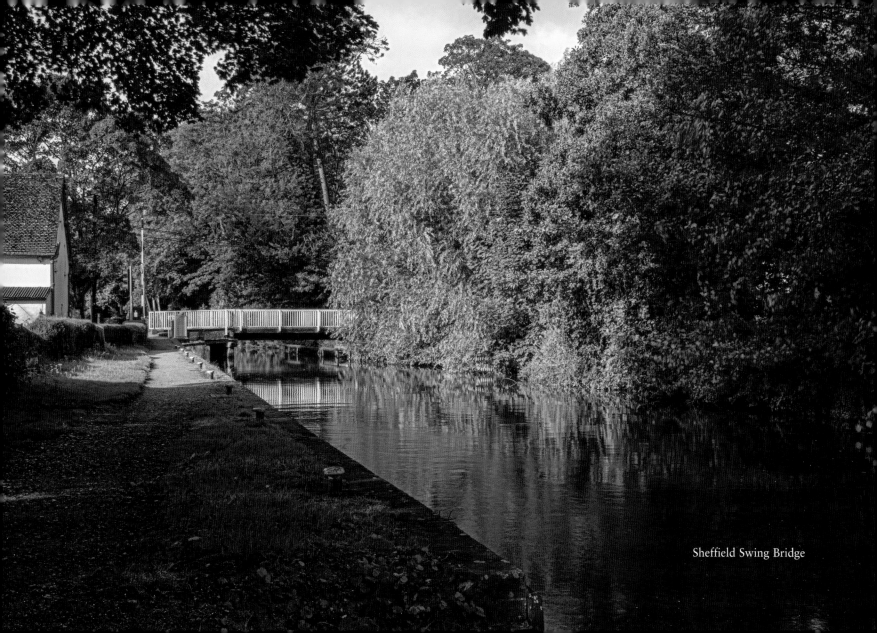

Sheffield Swing Bridge

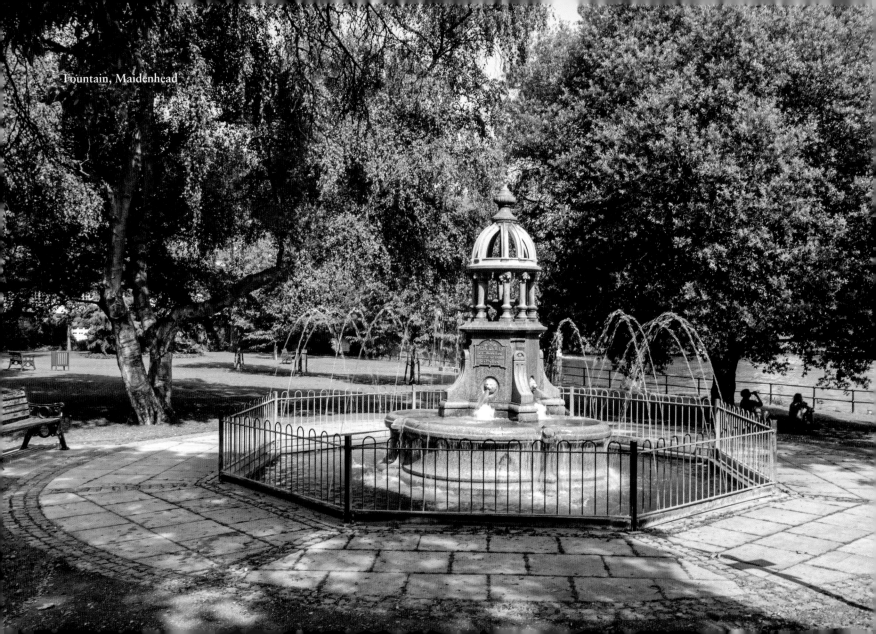

Fountain, Maidenhead

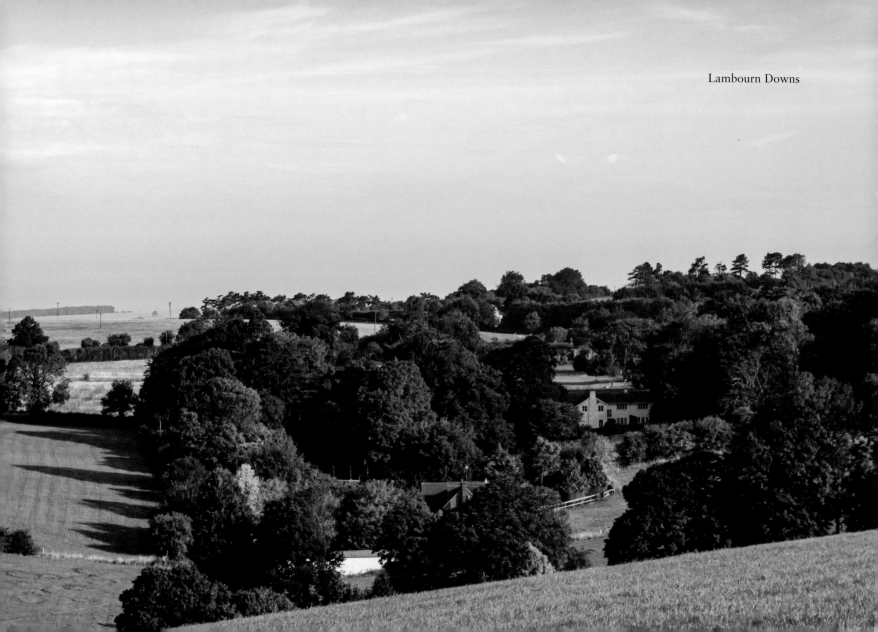
Lambourn Downs

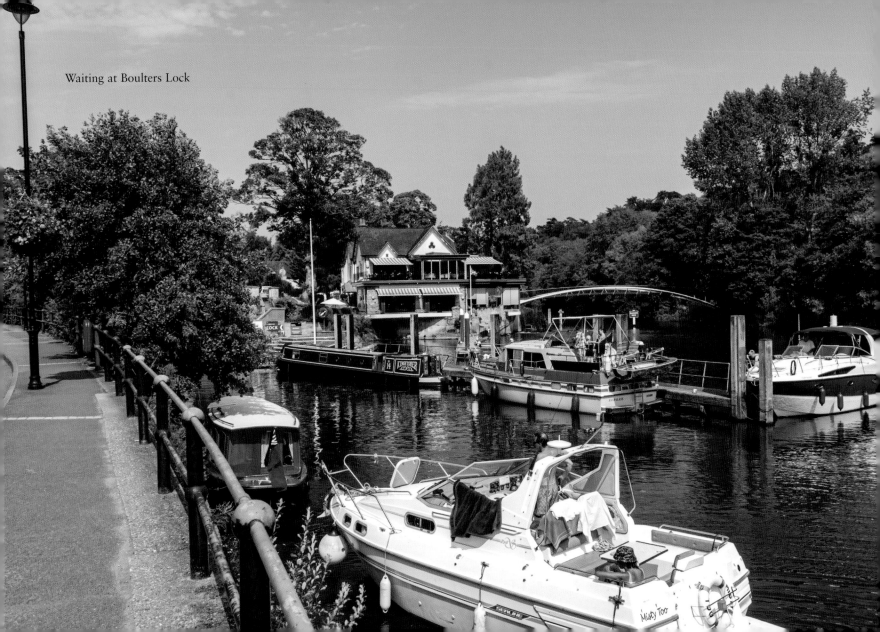

Waiting at Boulters Lock

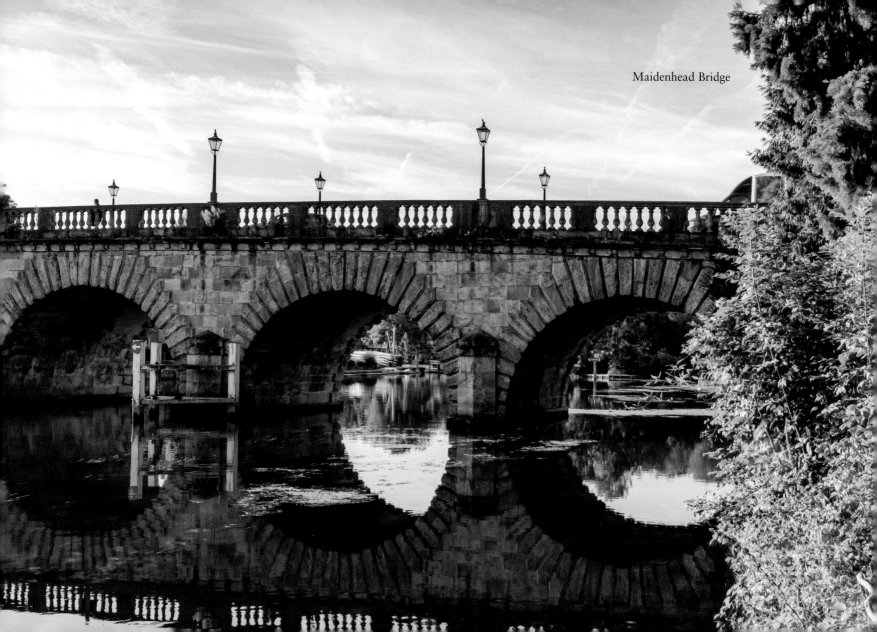

Maidenhead Bridge

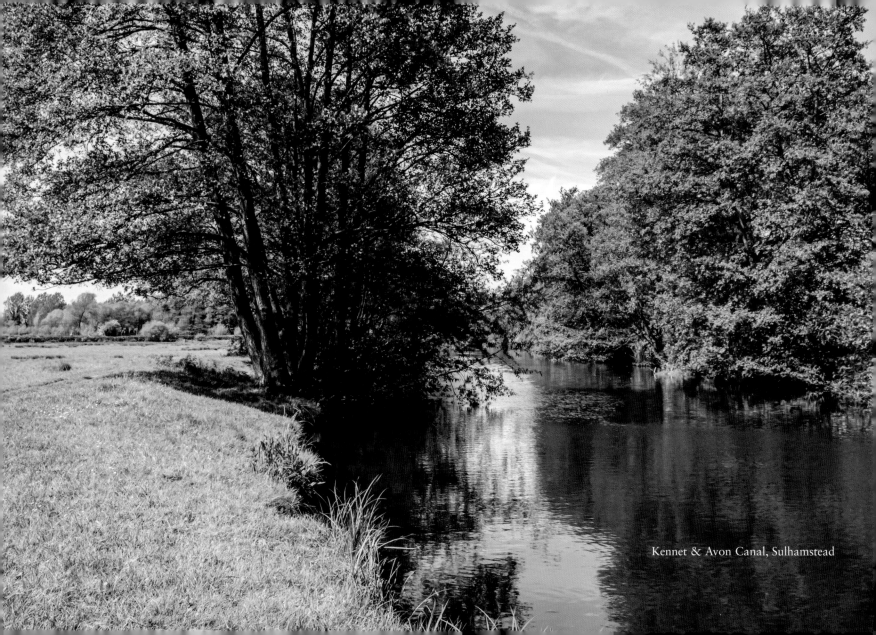

Kennet & Avon Canal, Sulhamstead

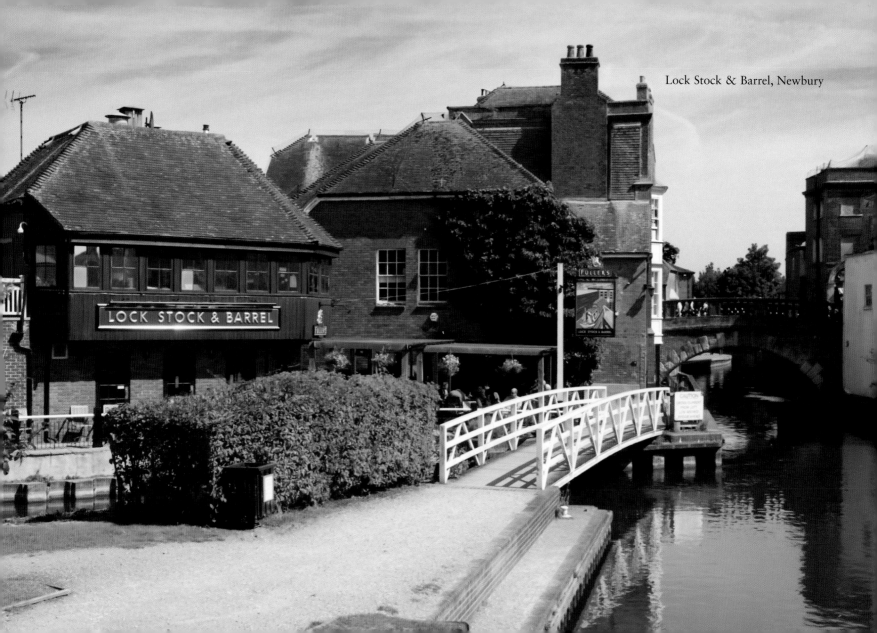

Lock Stock & Barrel, Newbury

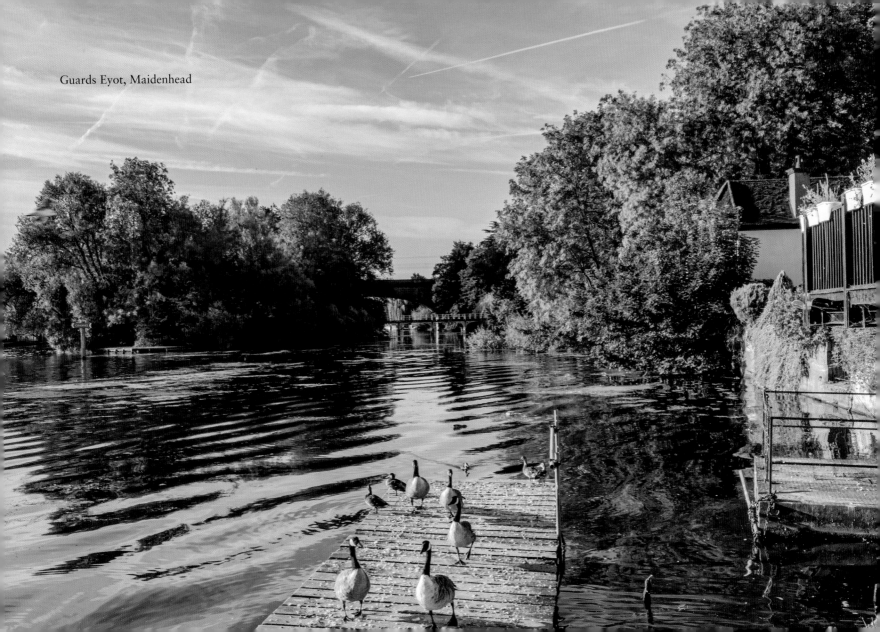

Guards Eyot, Maidenhead

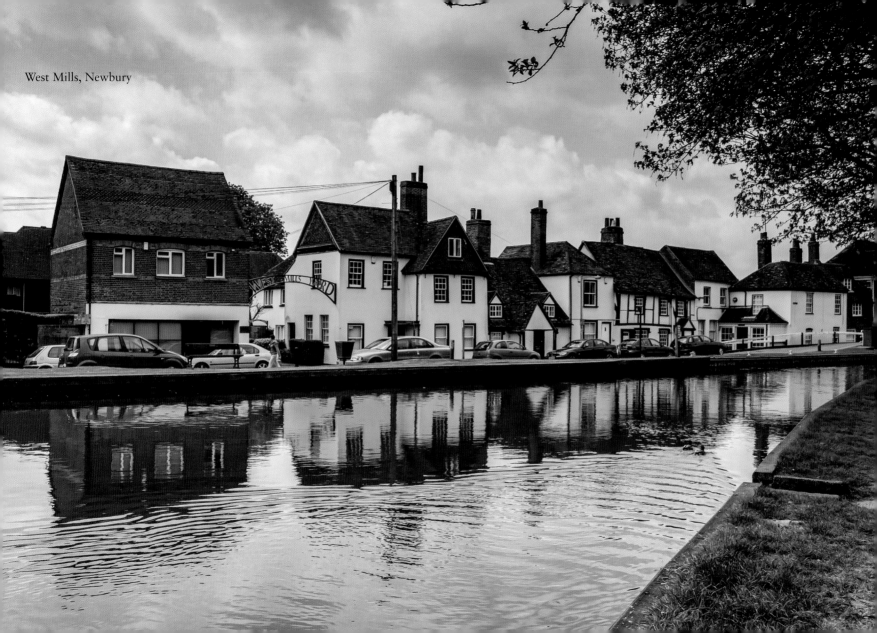

West Mills, Newbury

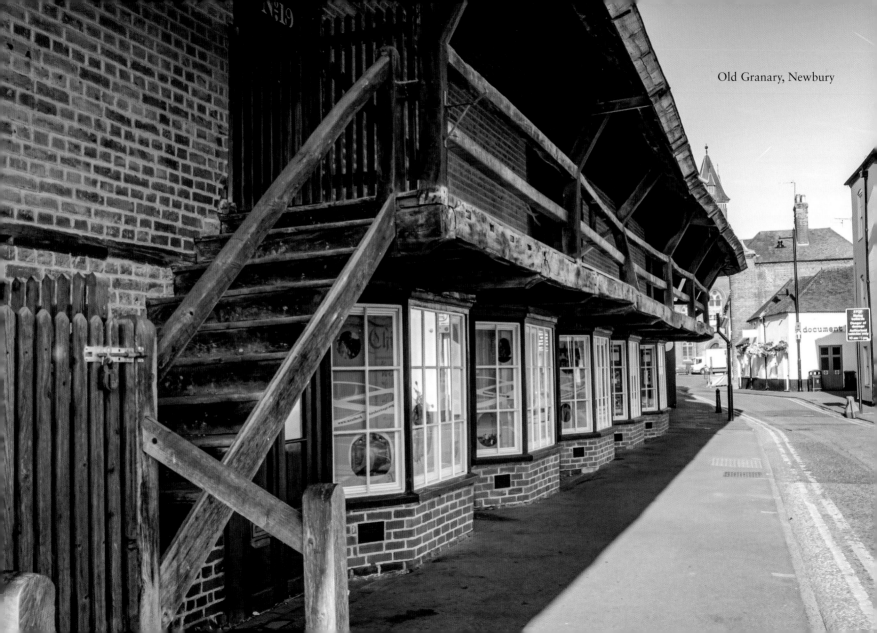

Old Granary, Newbury

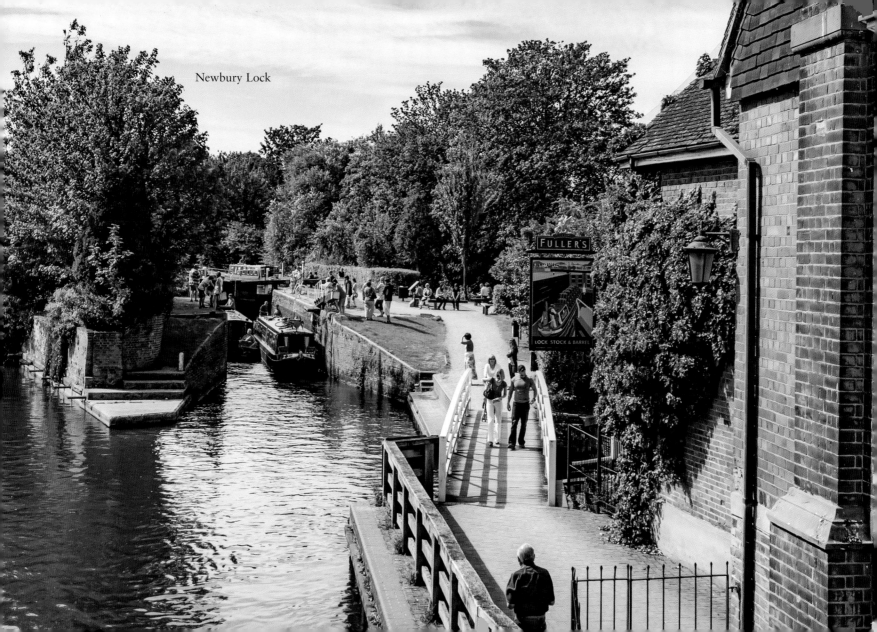

Newbury Lock

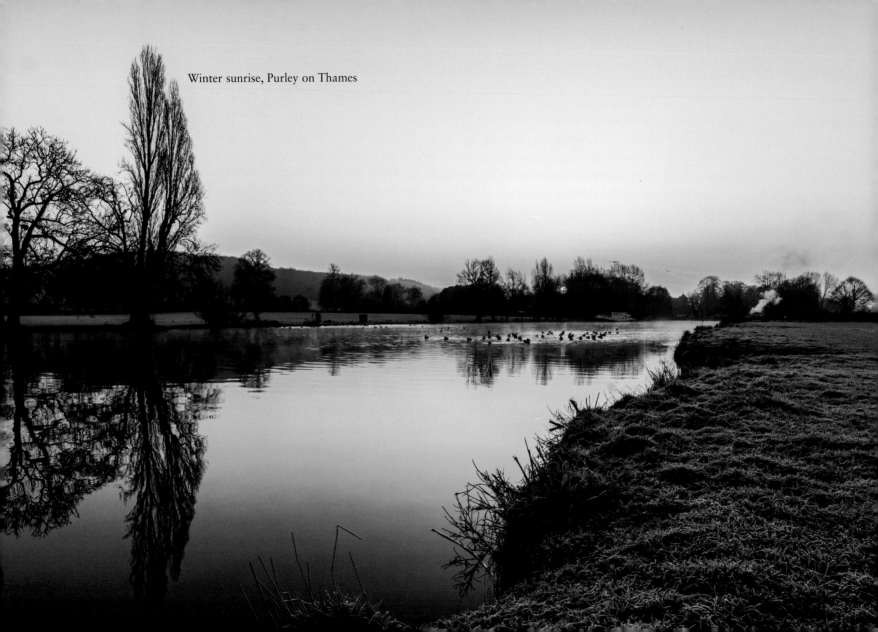

Winter sunrise, Purley on Thames

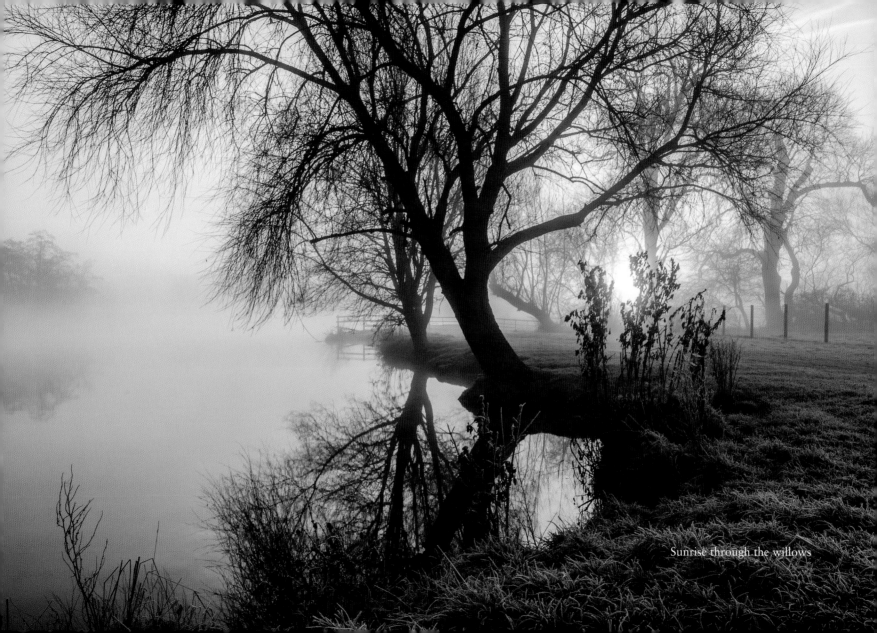

Sunrise through the willows

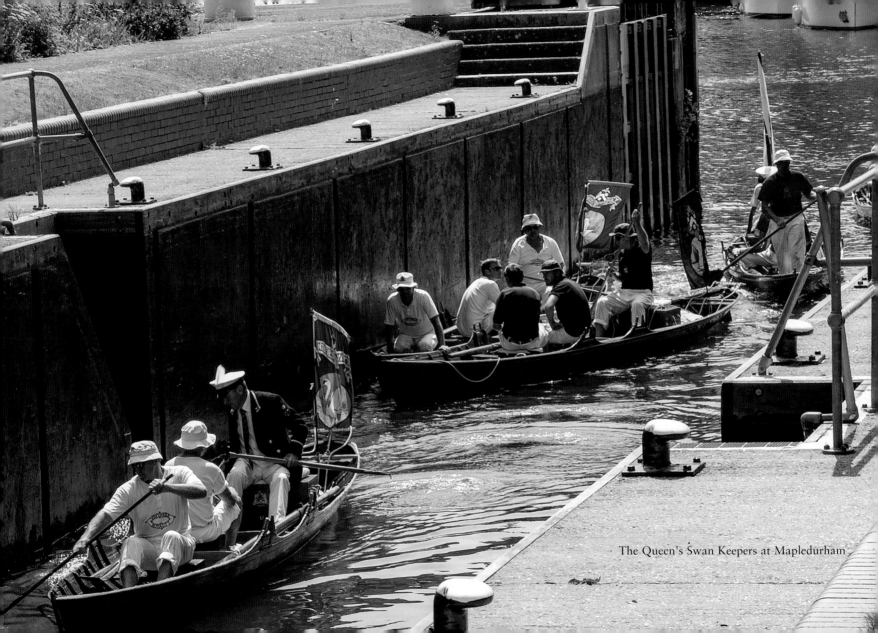

The Queen's Swan Keepers at Mapledurham

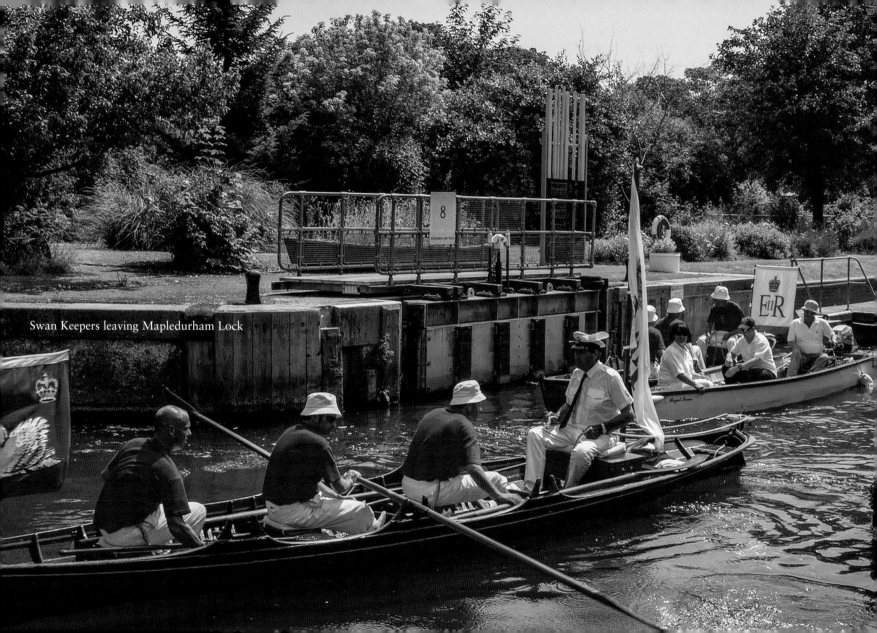
Swan Keepers leaving Mapledurham Lock

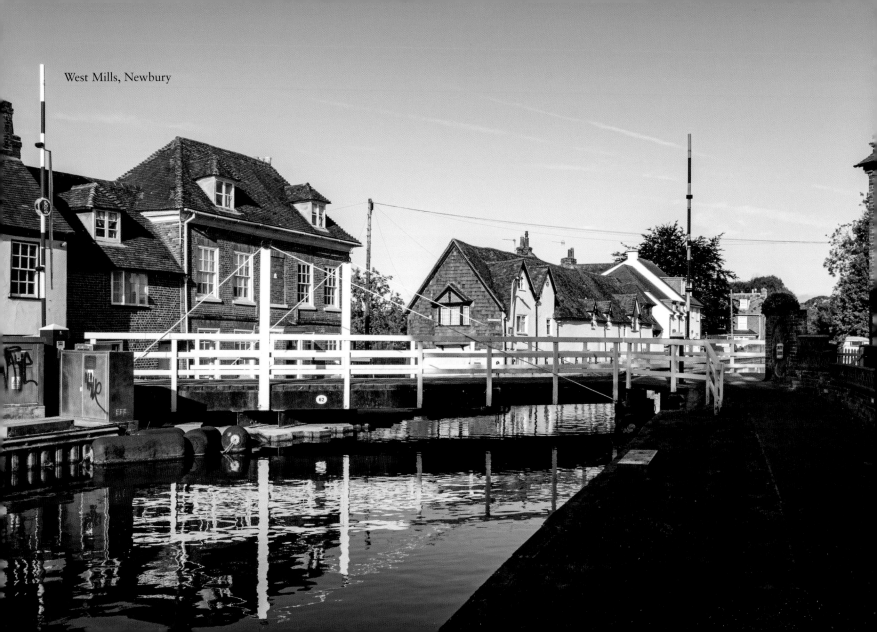
West Mills, Newbury

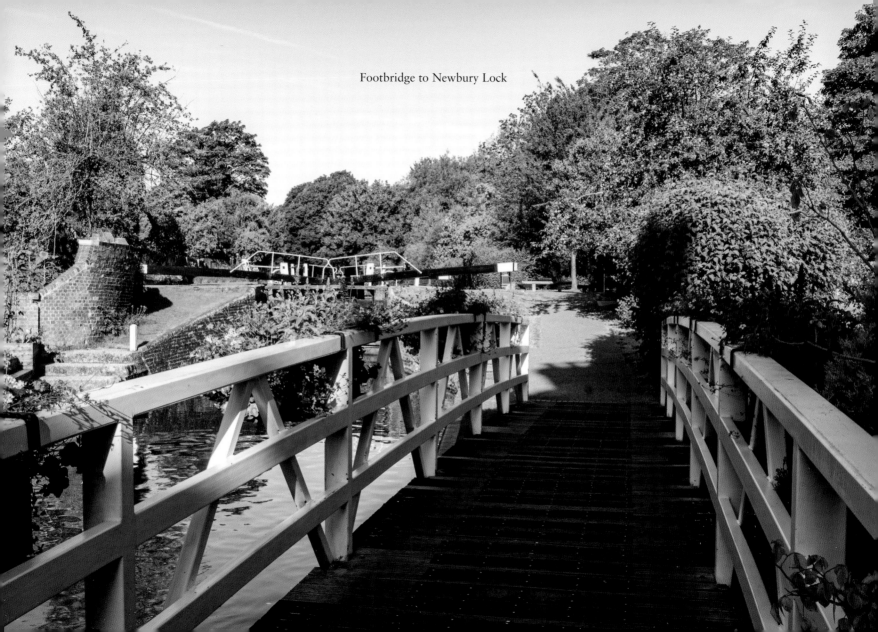
Footbridge to Newbury Lock

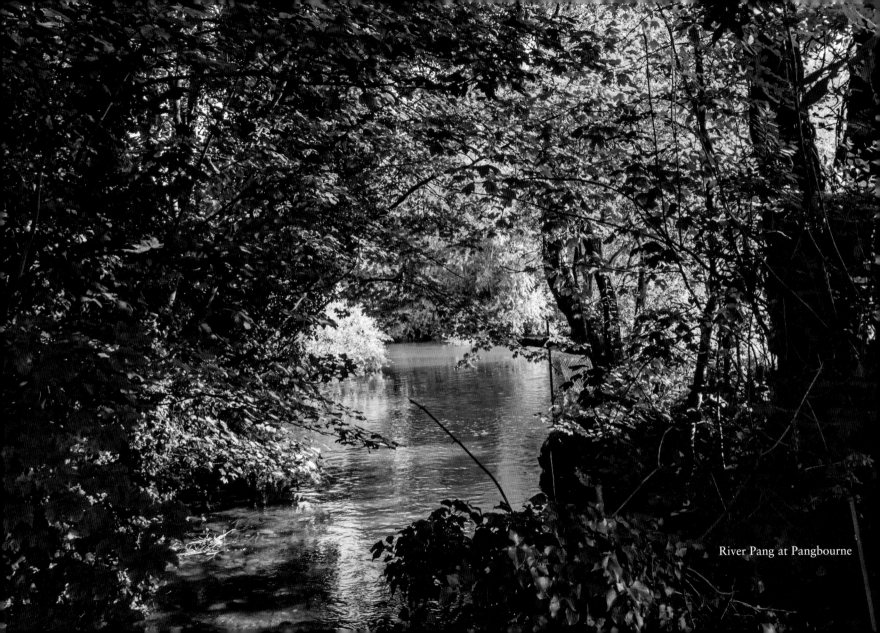

River Pang at Pangbourne

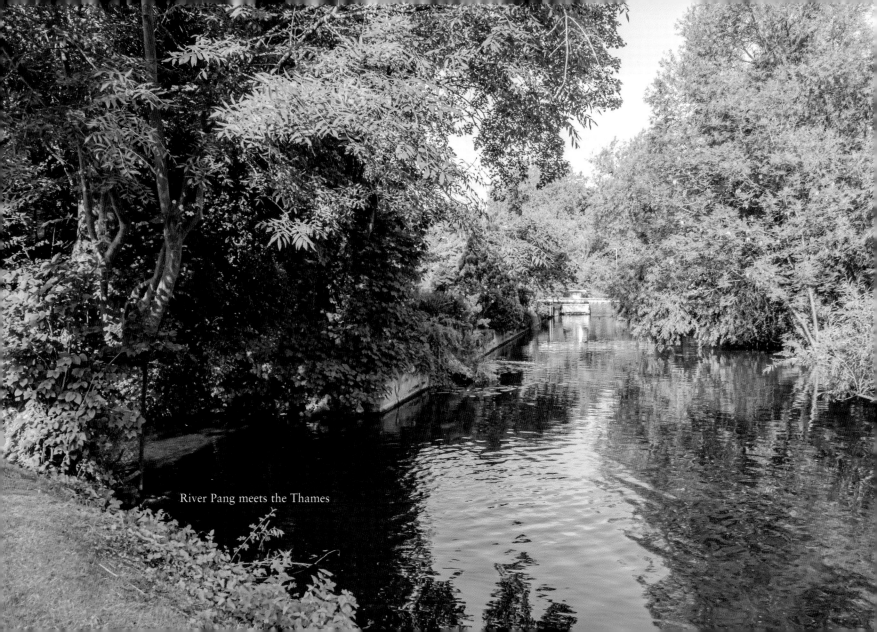

River Pang meets the Thames

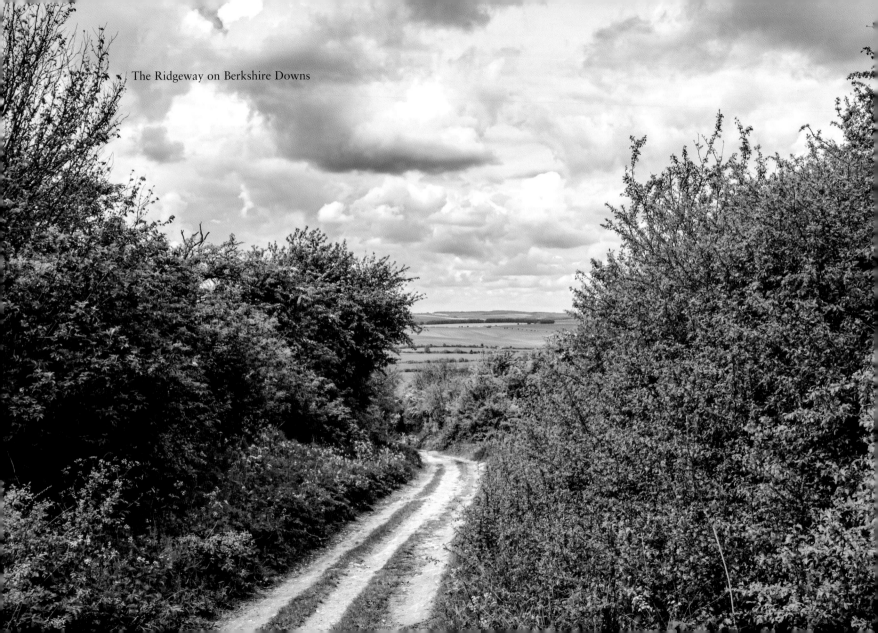
The Ridgeway on Berkshire Downs

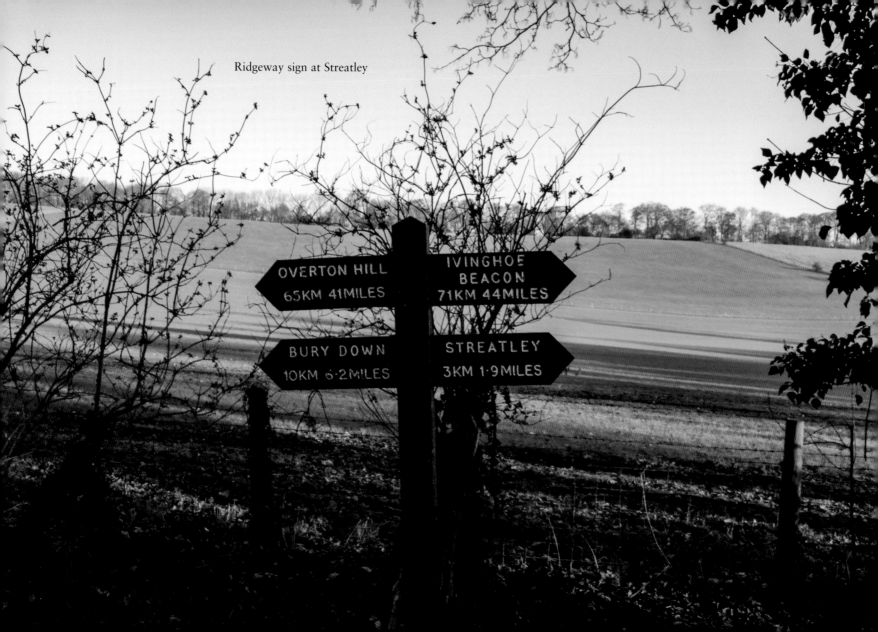

Ridgeway sign at Streatley

OVERTON HILL
65KM 41MILES

IVINGHOE
BEACON
71KM 44MILES

BURY DOWN
10KM 6·2MILES

STREATLEY
3KM 1·9MILES

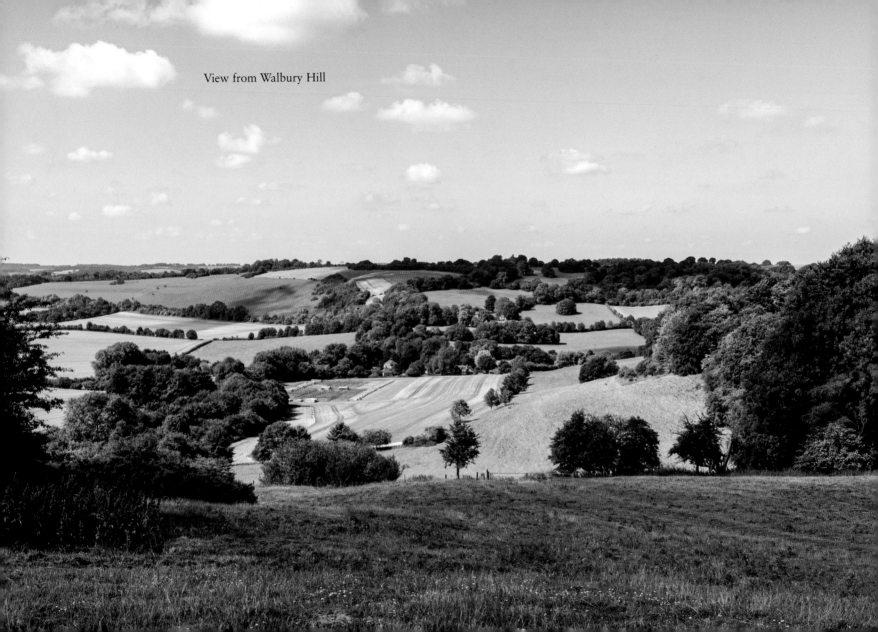
View from Walbury Hill

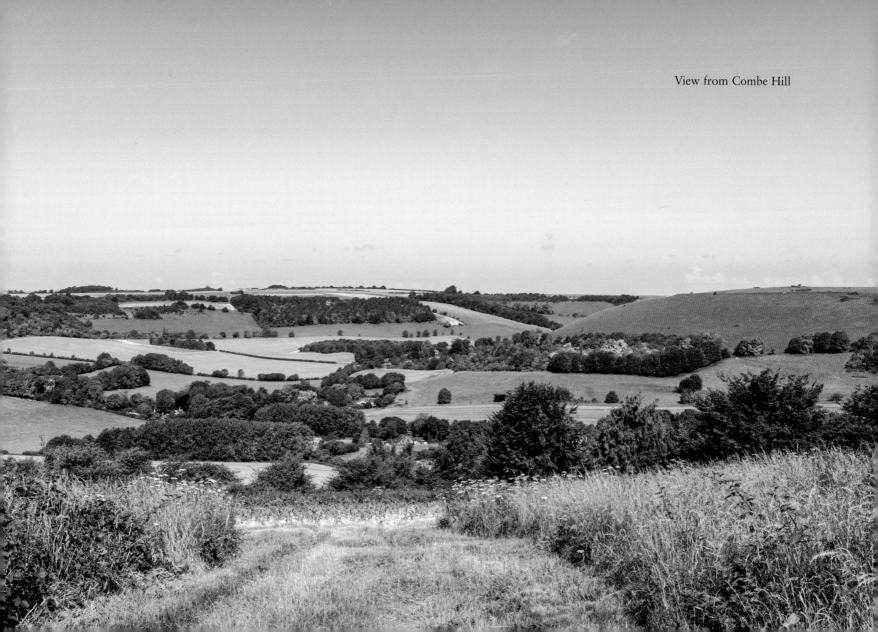

View from Combe Hill

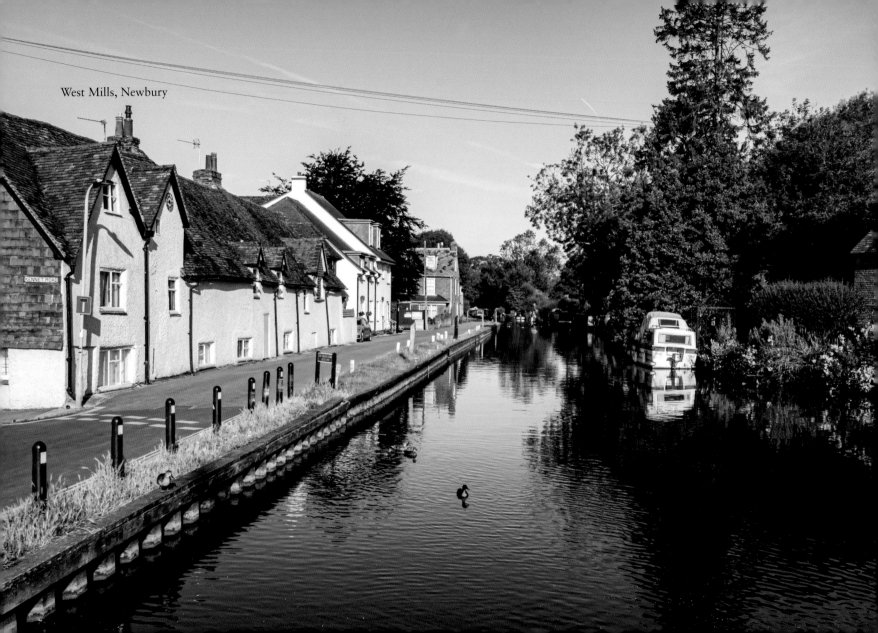

West Mills, Newbury

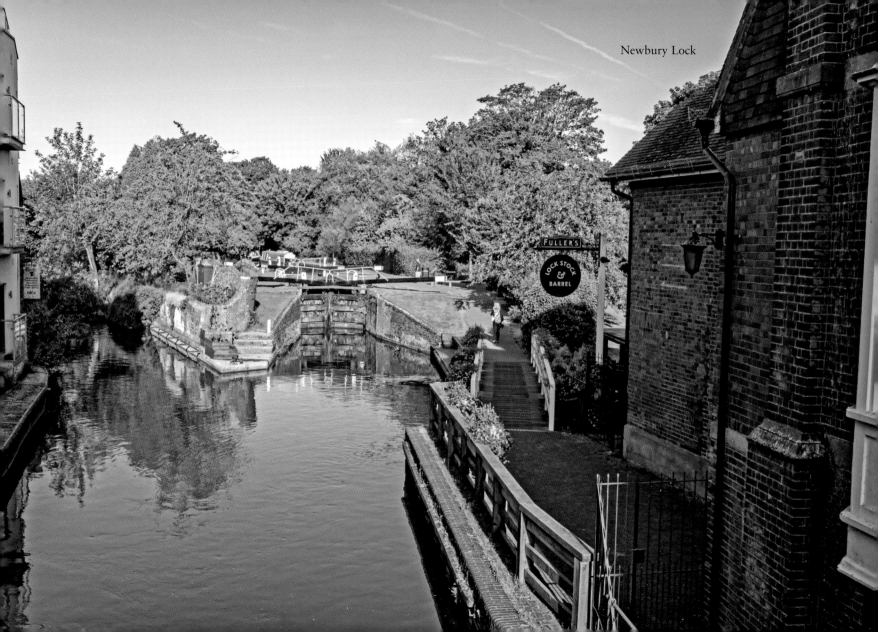

Newbury Lock

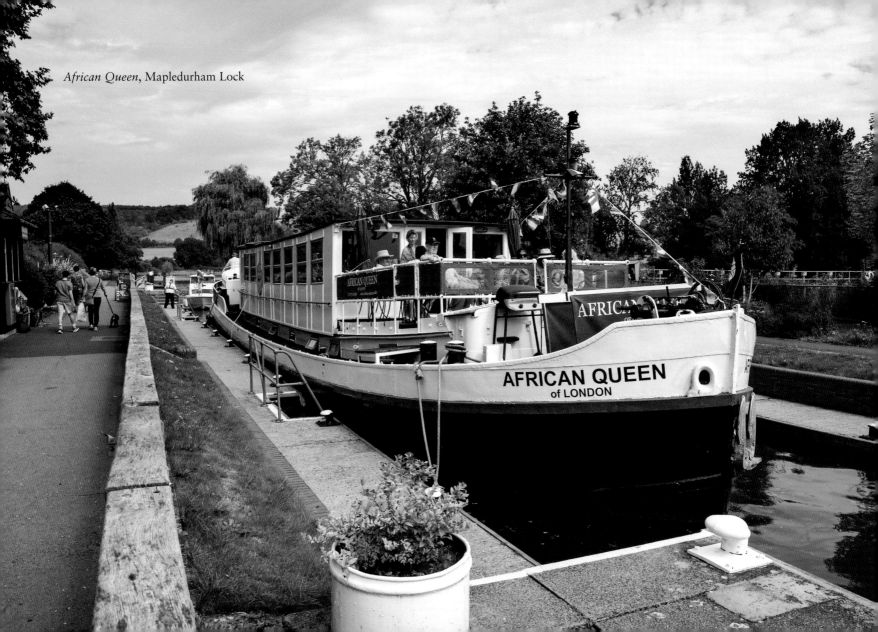

African Queen, Mapledurham Lock

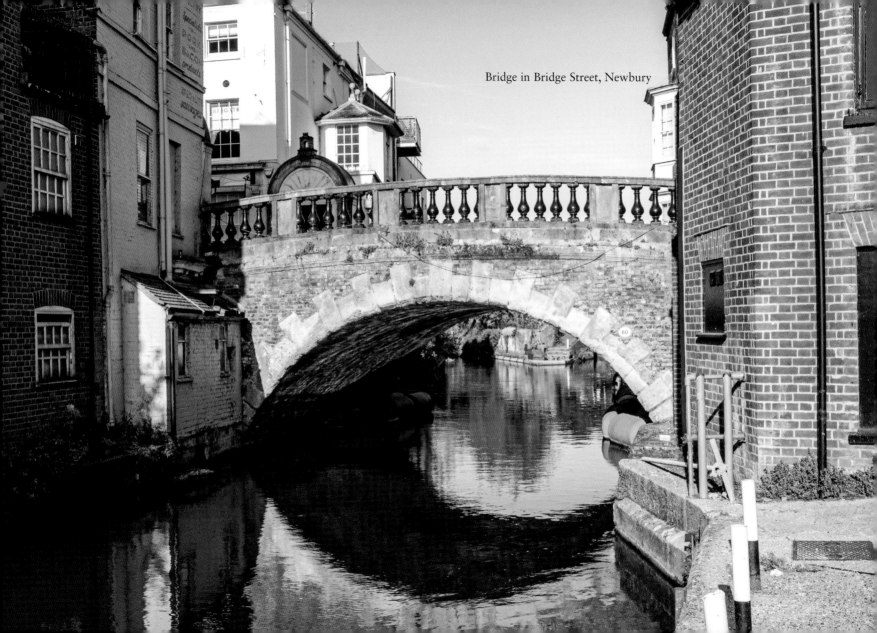

Bridge in Bridge Street, Newbury

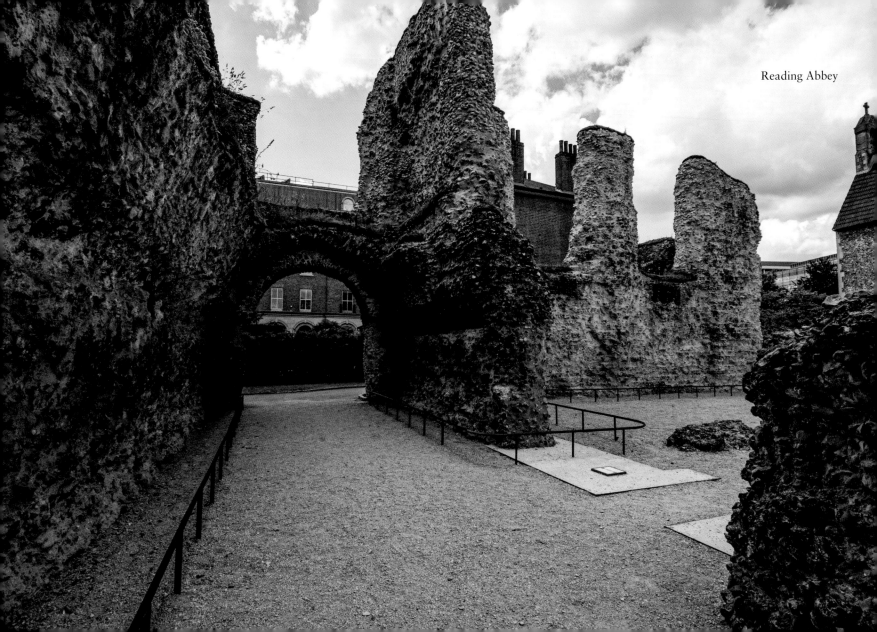

Reading Abbey

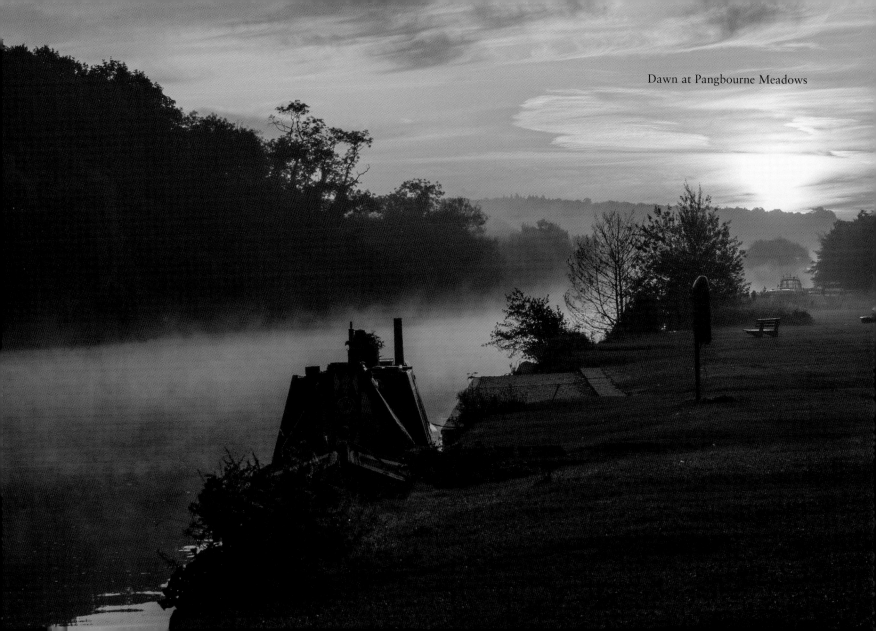
Dawn at Pangbourne Meadows

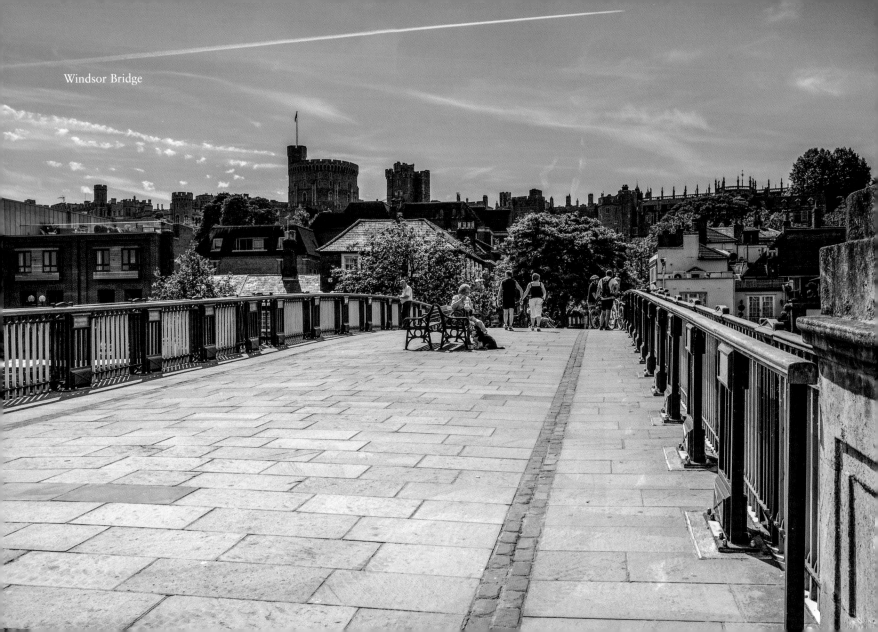

Windsor Bridge

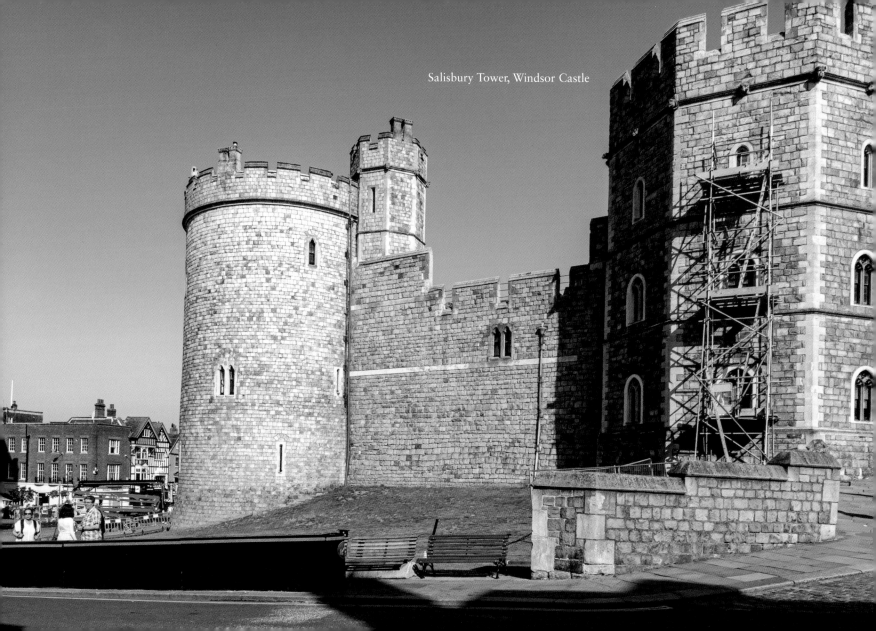
Salisbury Tower, Windsor Castle

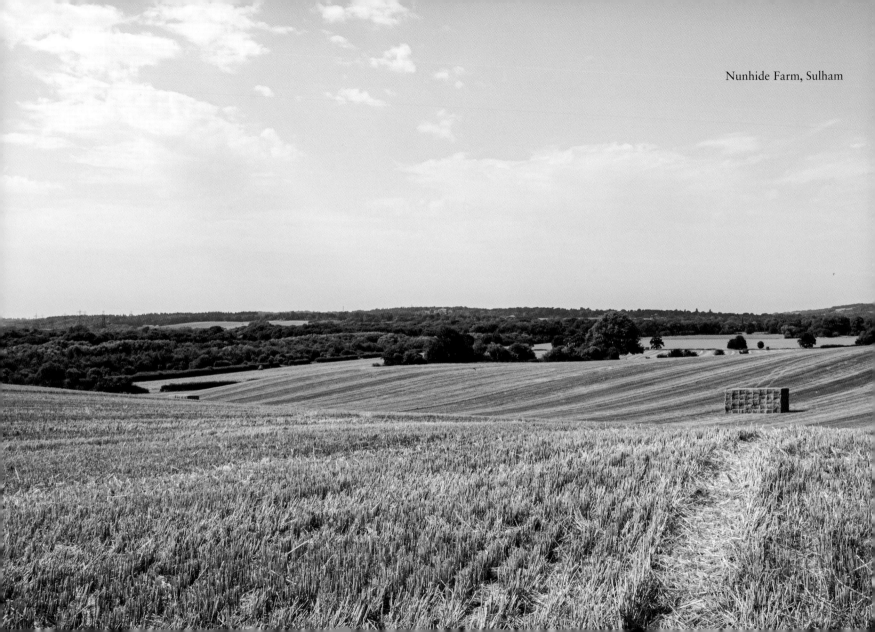
Nunhide Farm, Sulham

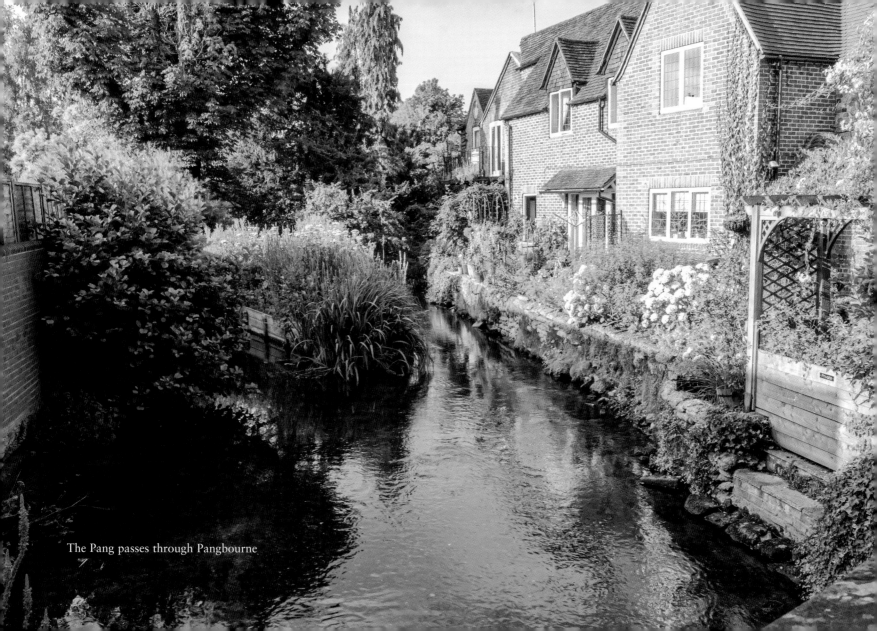
The Pang passes through Pangbourne

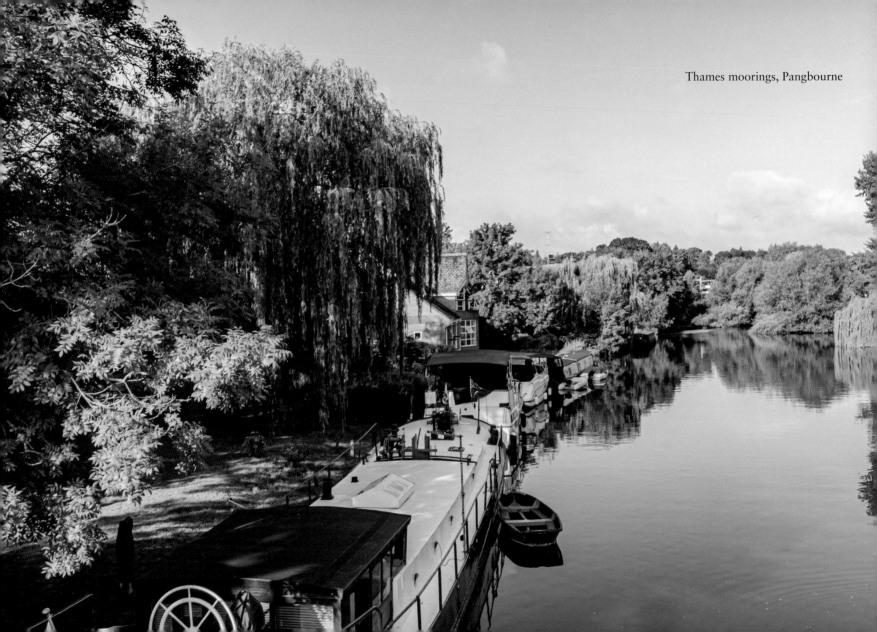

Thames moorings, Pangbourne

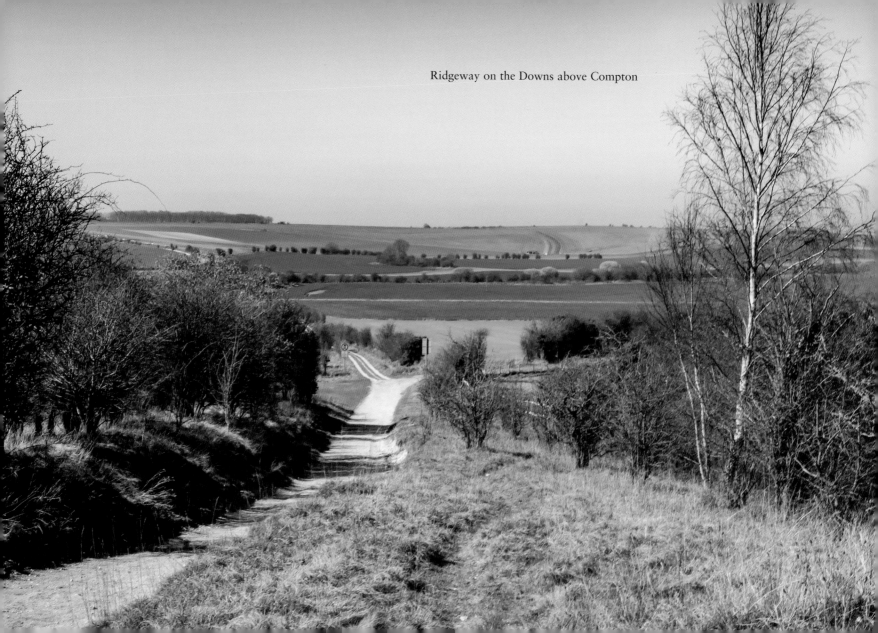

Ridgeway on the Downs above Compton

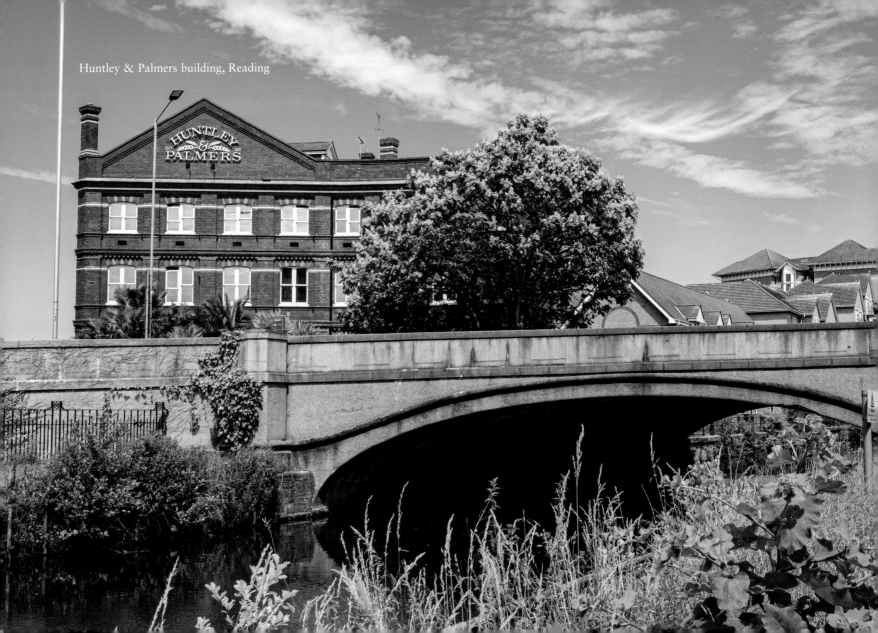

Huntley & Palmers building, Reading

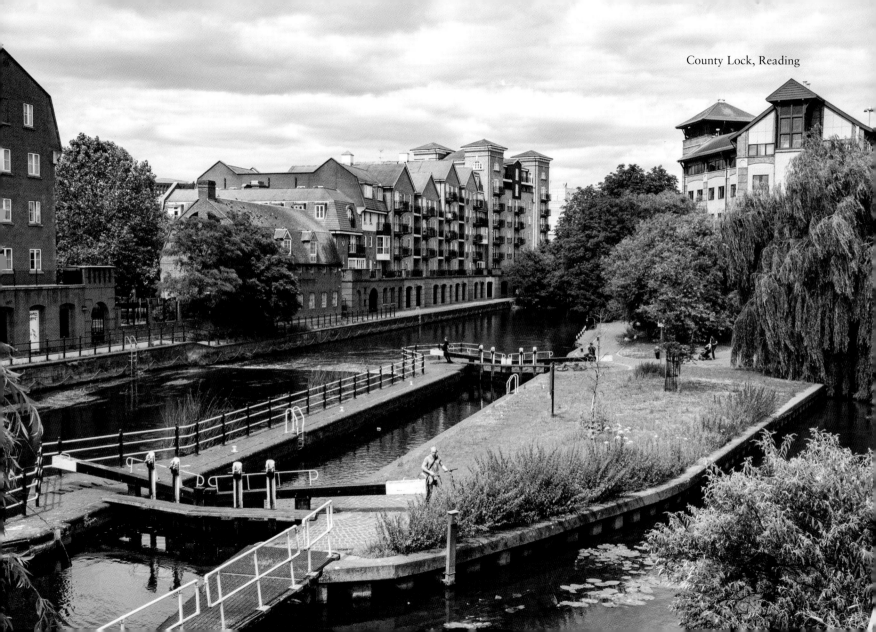

County Lock, Reading

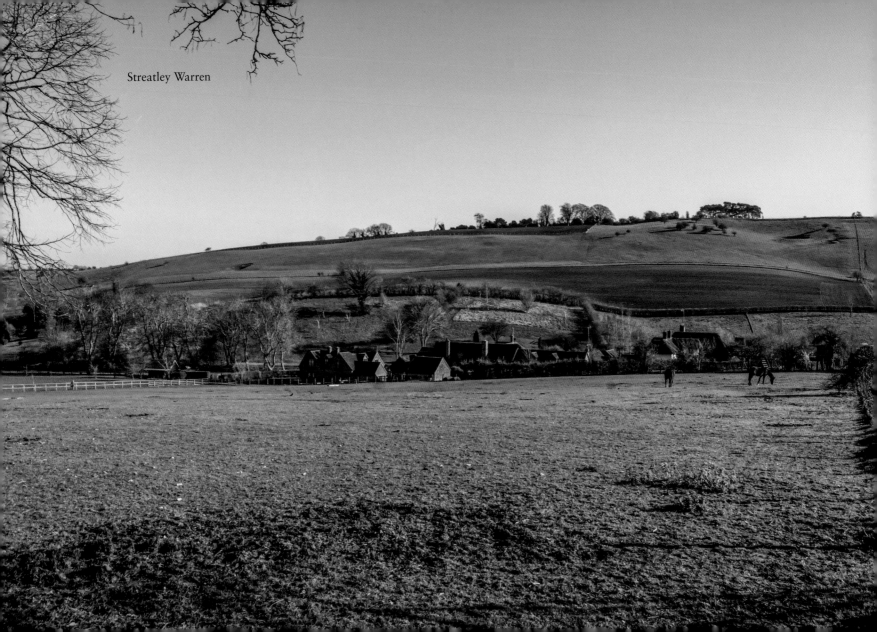

Streatley Warren

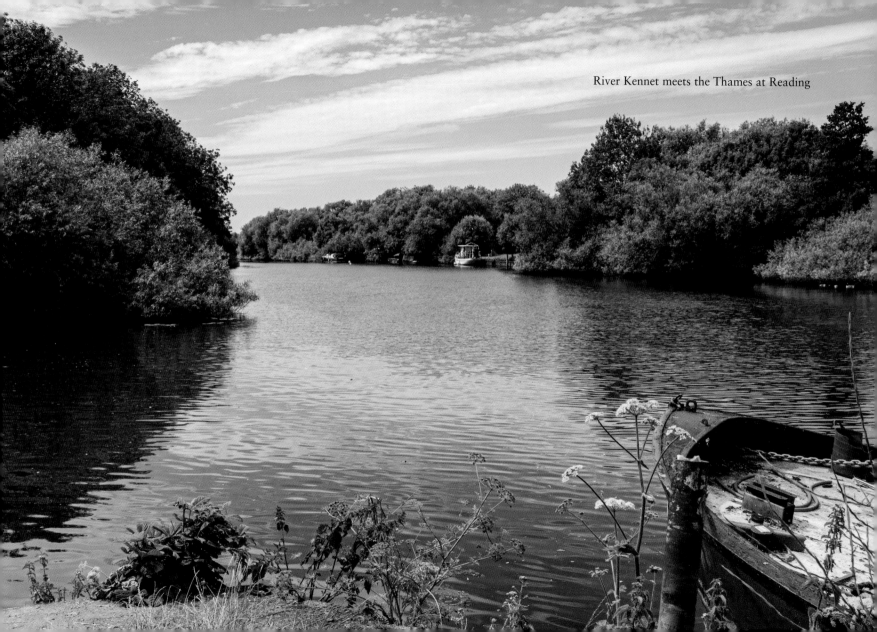
River Kennet meets the Thames at Reading

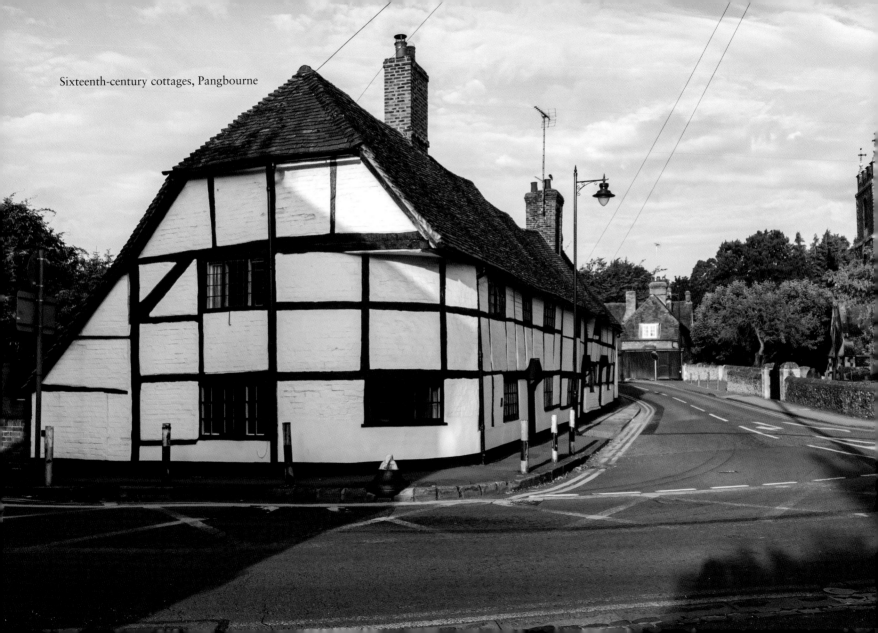

Sixteenth-century cottages, Pangbourne

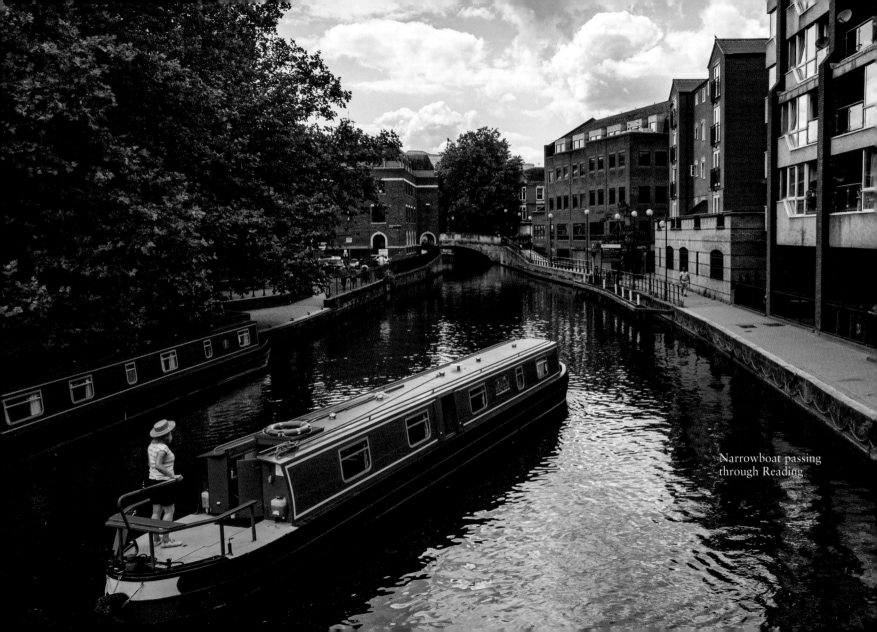

Narrowboat passing
through Reading

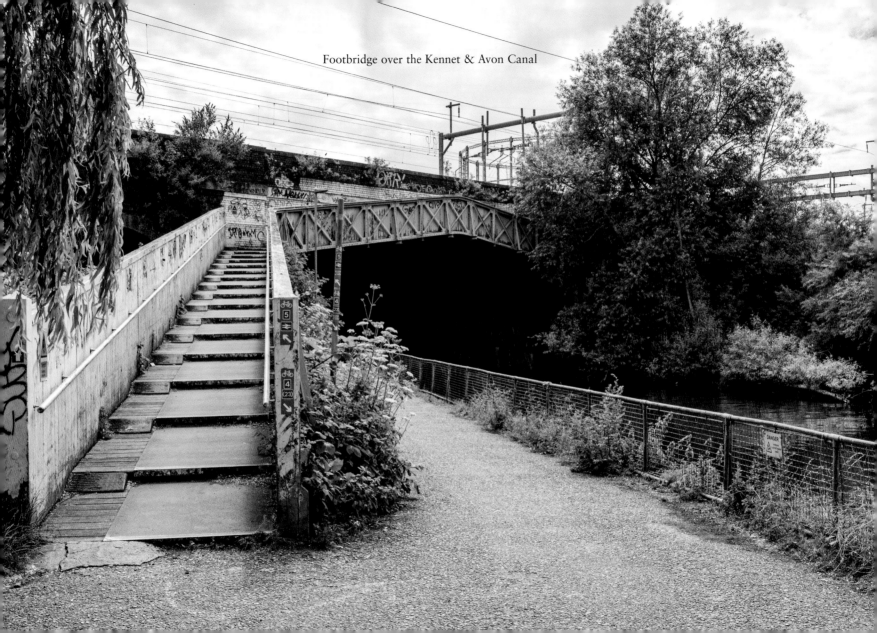
Footbridge over the Kennet & Avon Canal

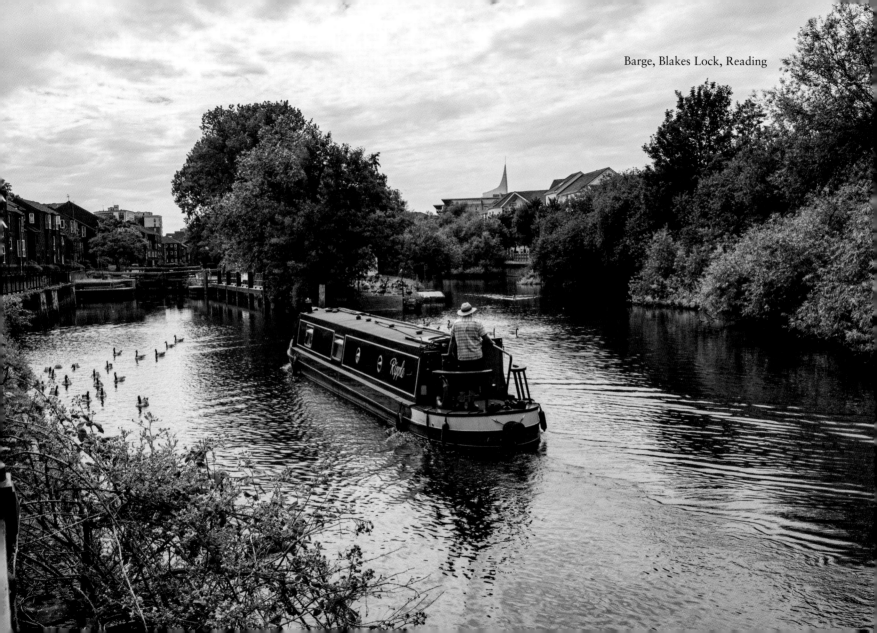

Barge, Blakes Lock, Reading

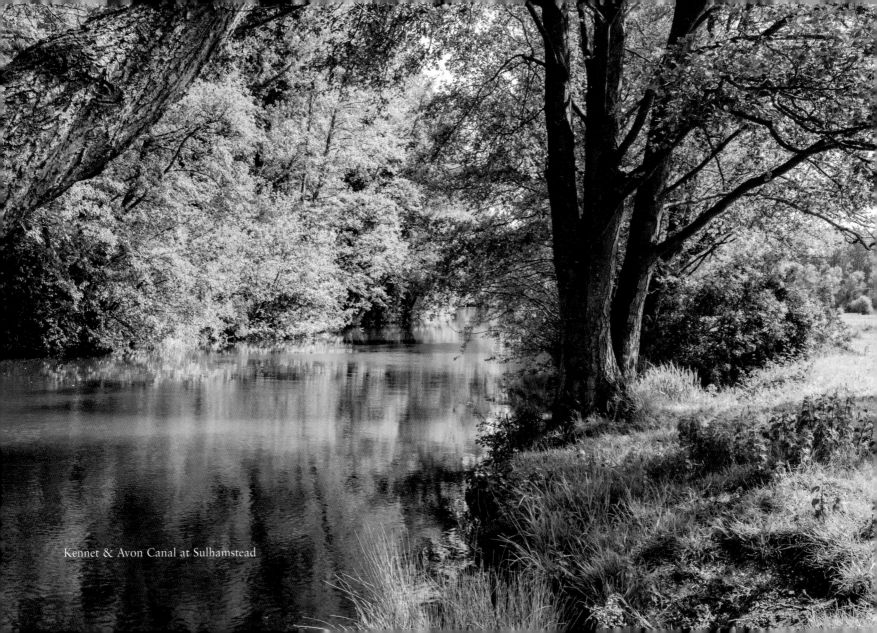
Kennet & Avon Canal at Sulhamstead

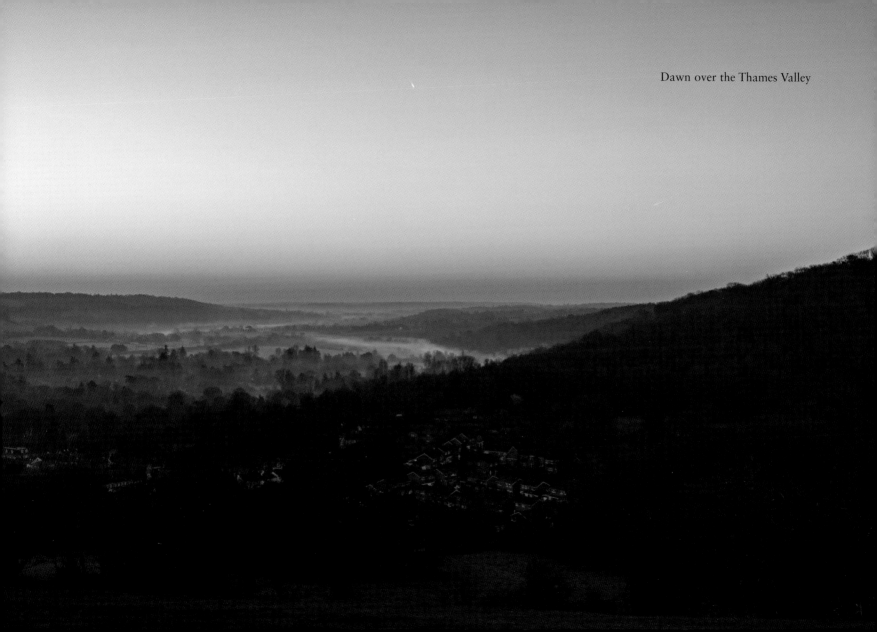

Dawn over the Thames Valley

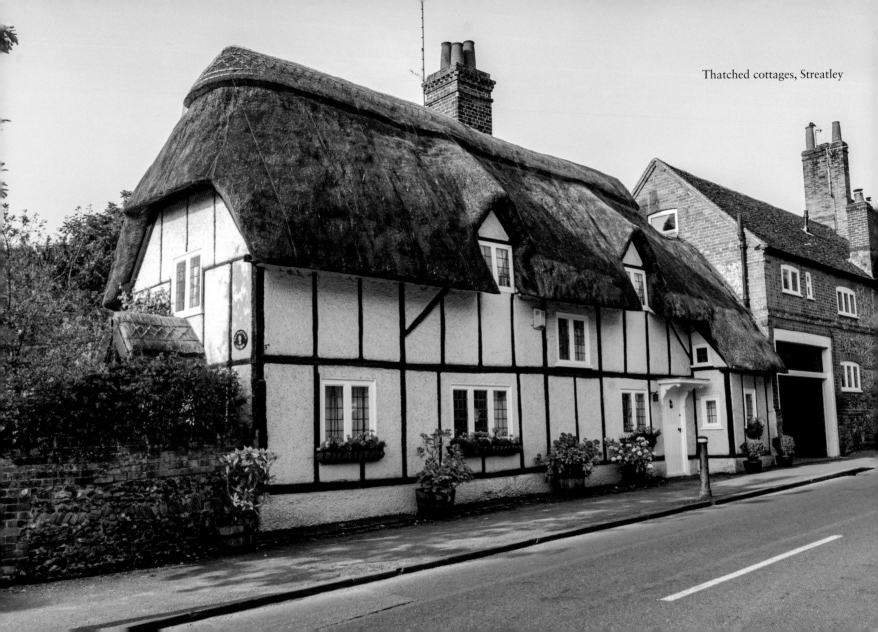
Thatched cottages, Streatley

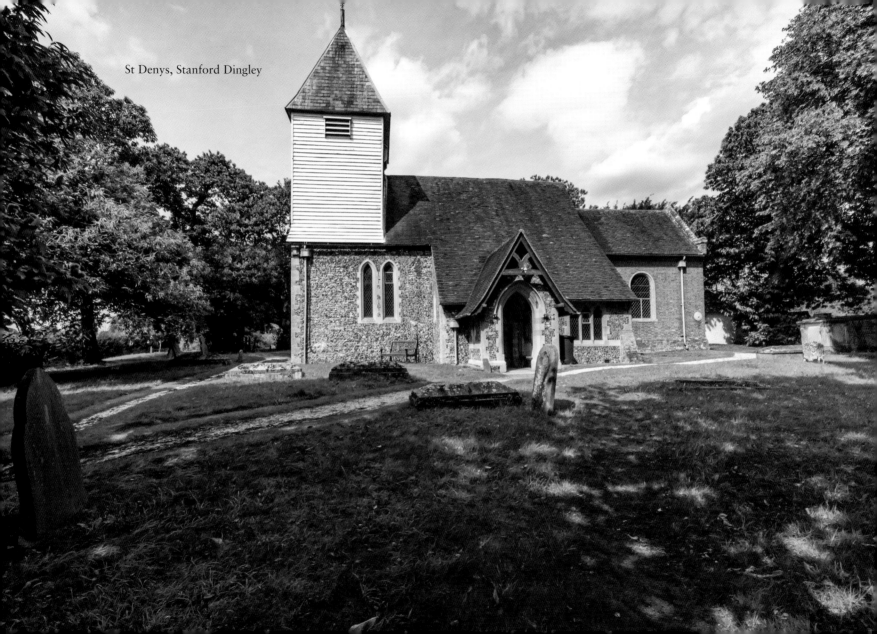

St Denys, Stanford Dingley

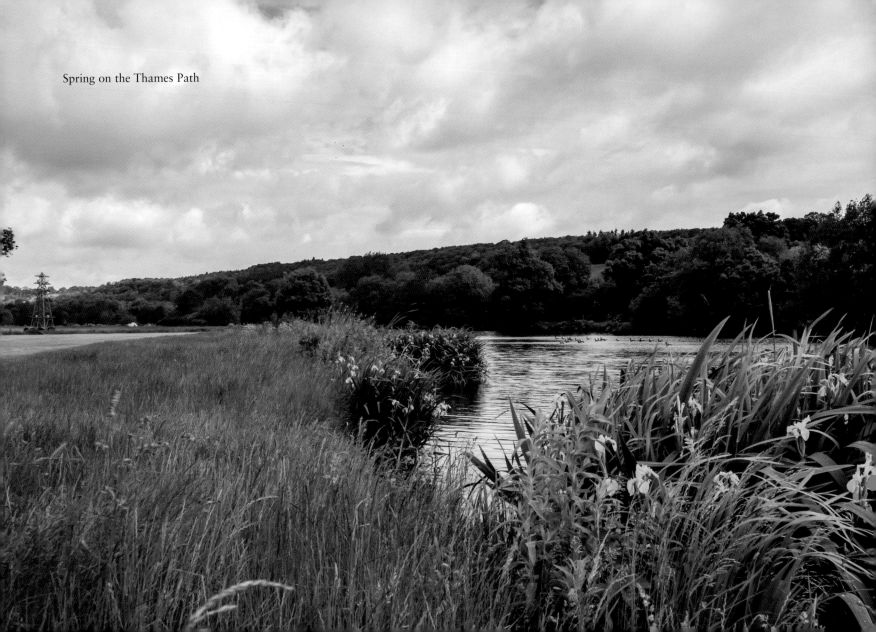
Spring on the Thames Path

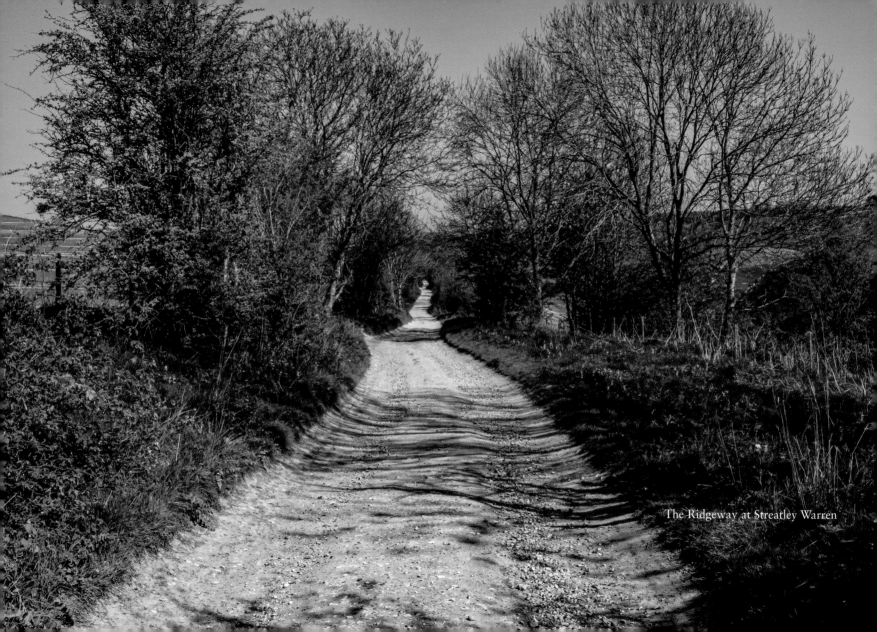

The Ridgeway at Streatley Warren

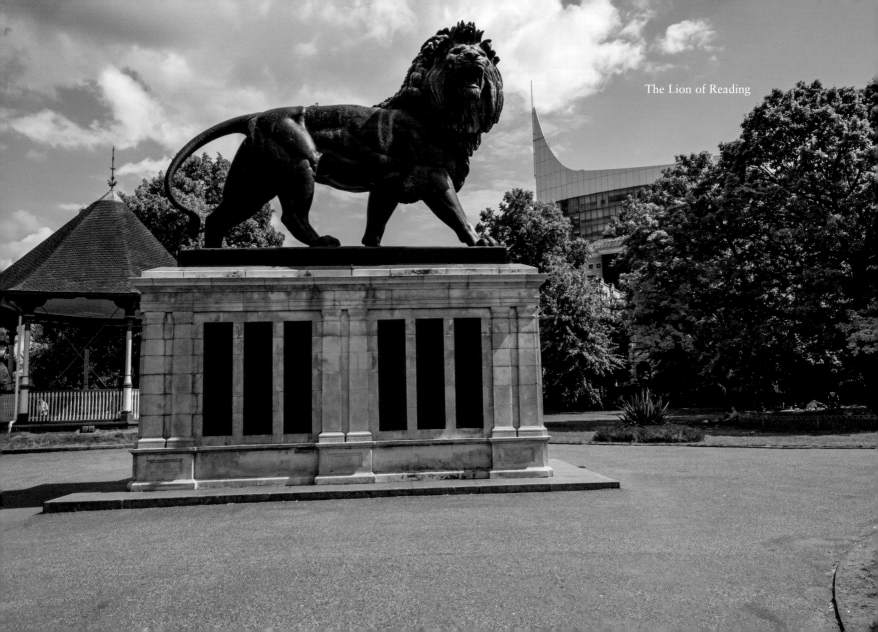

The Lion of Reading

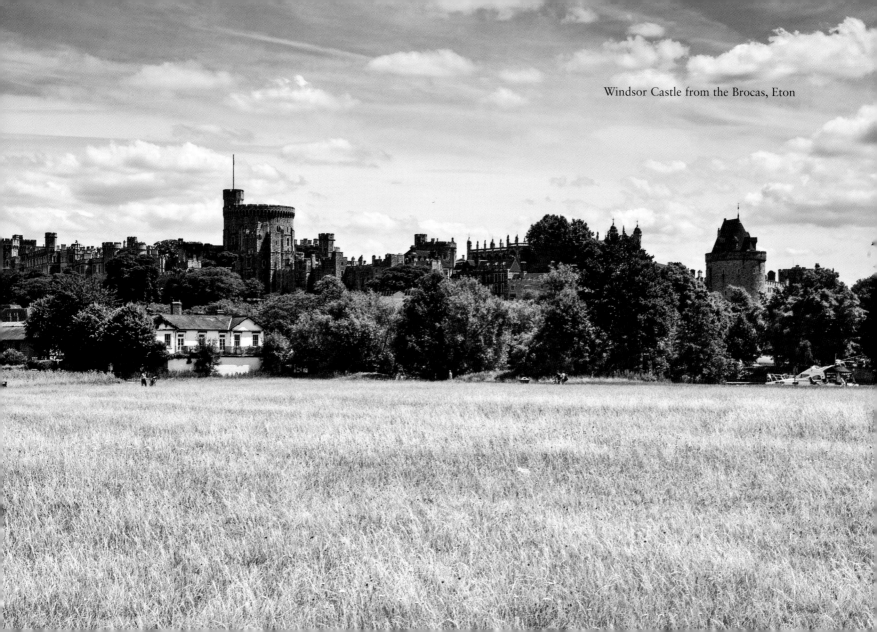

Windsor Castle from the Brocas, Eton

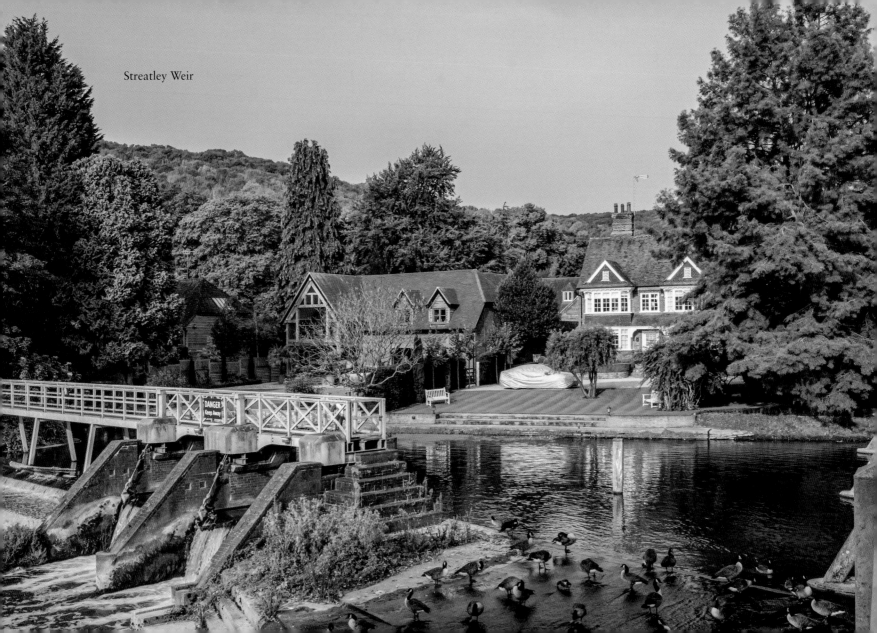

Streatley Weir

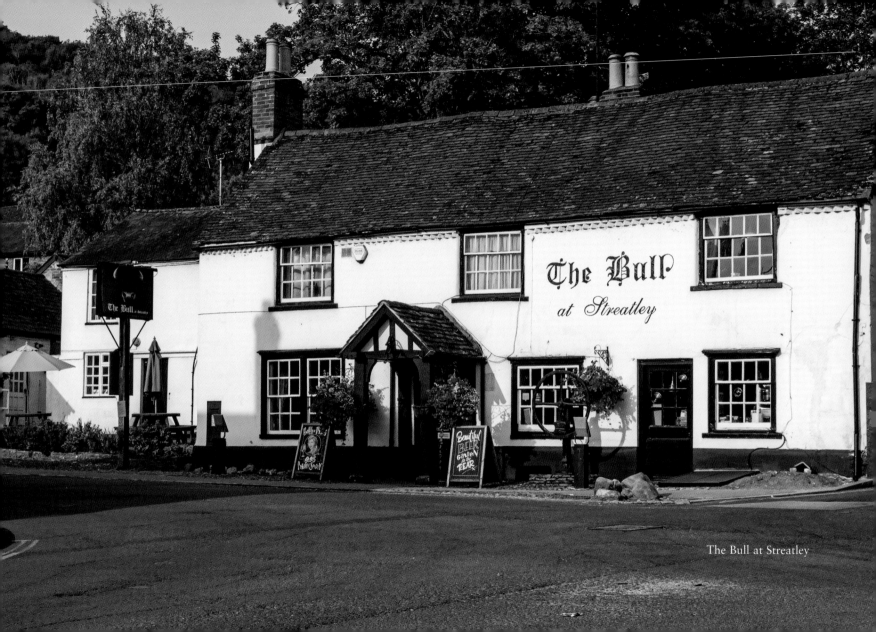

The Bull at Streatley

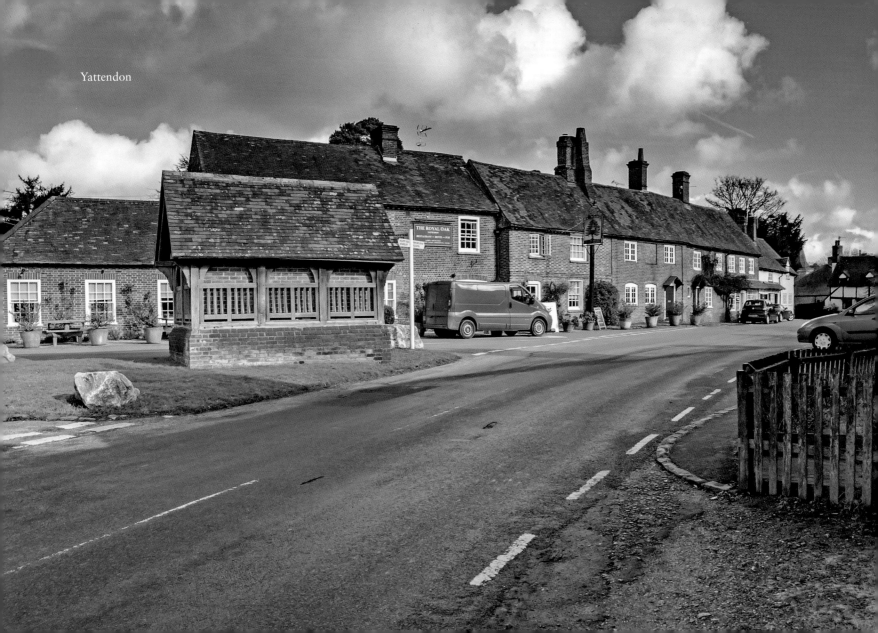

Yattendon

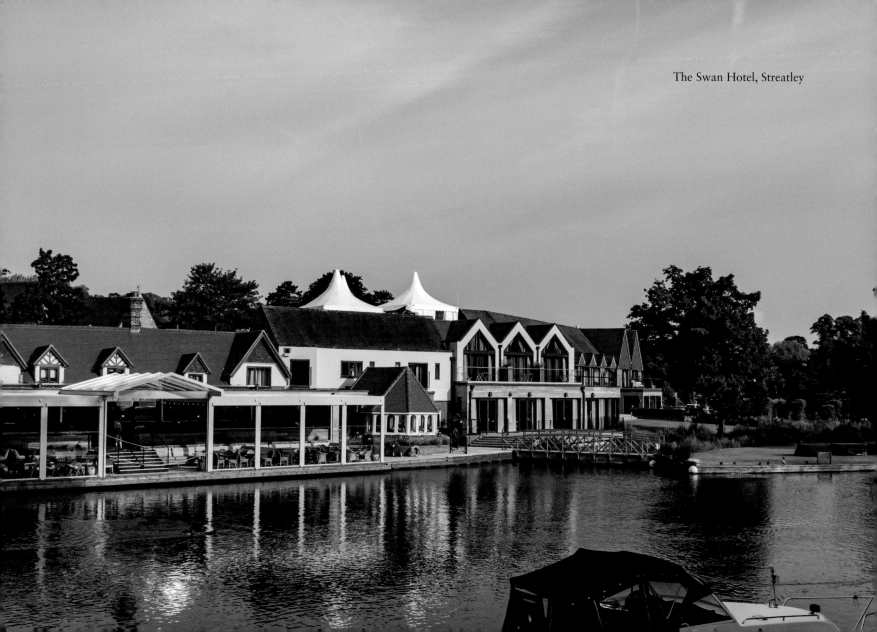

The Swan Hotel, Streatley

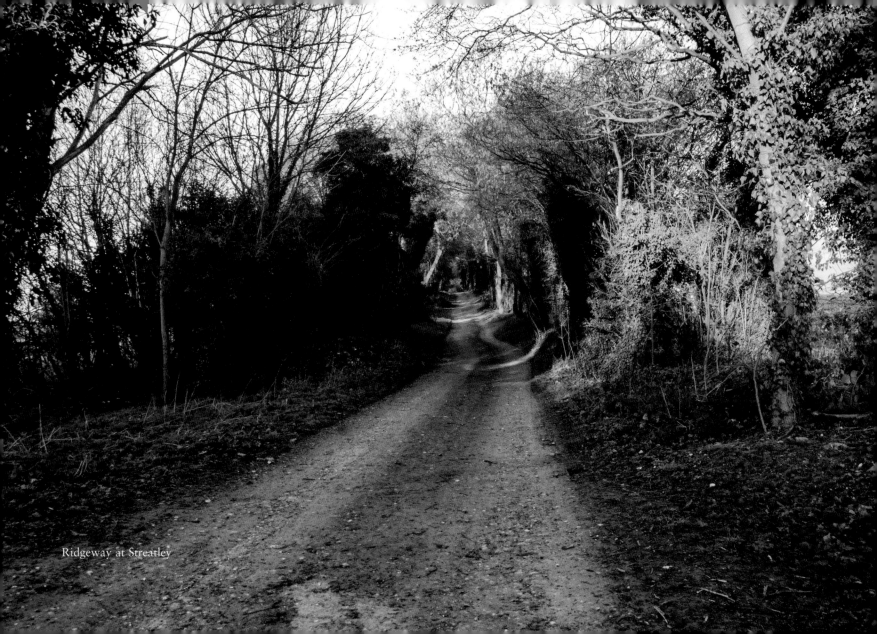

Ridgeway at Streatley

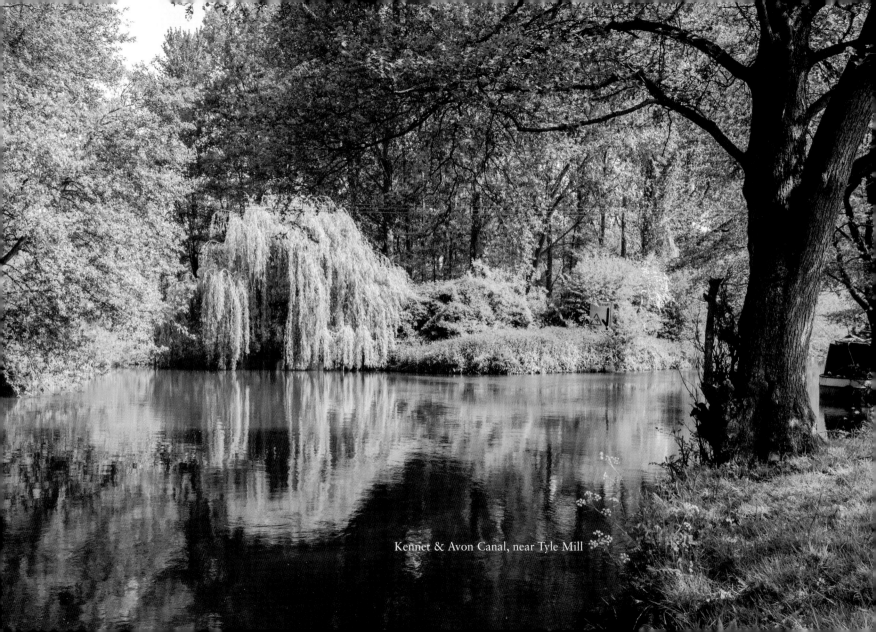

Kennet & Avon Canal, near Tyle Mill

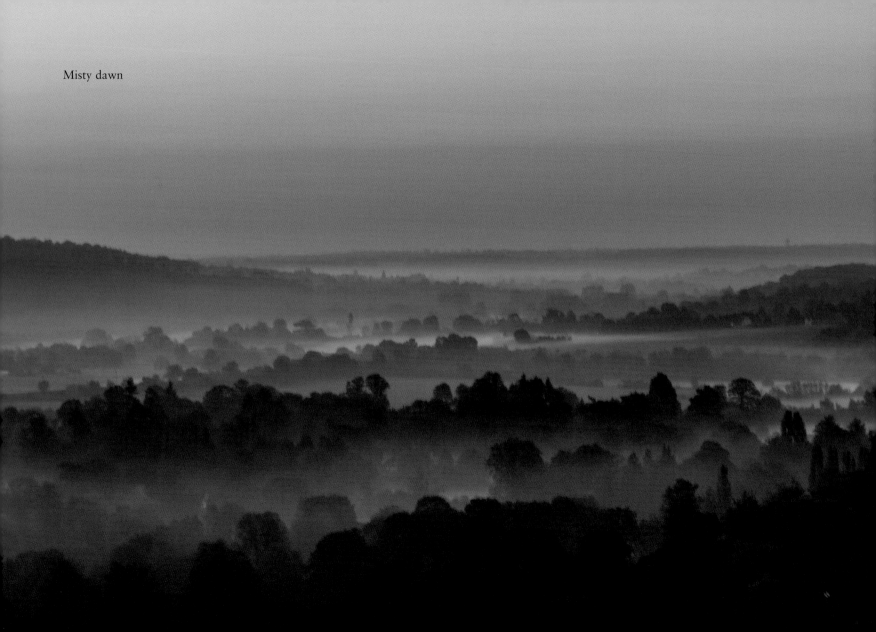

Misty dawn

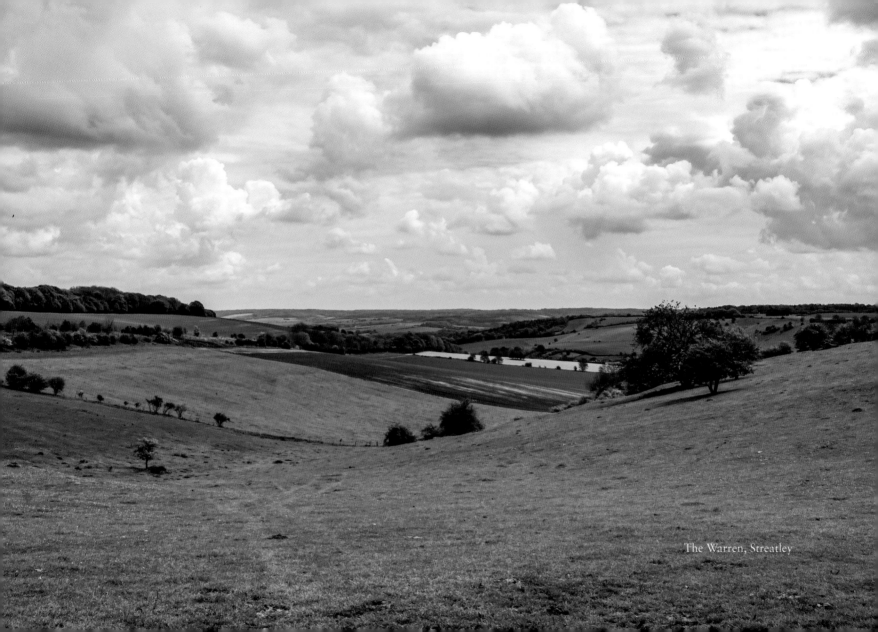
The Warren, Streatley

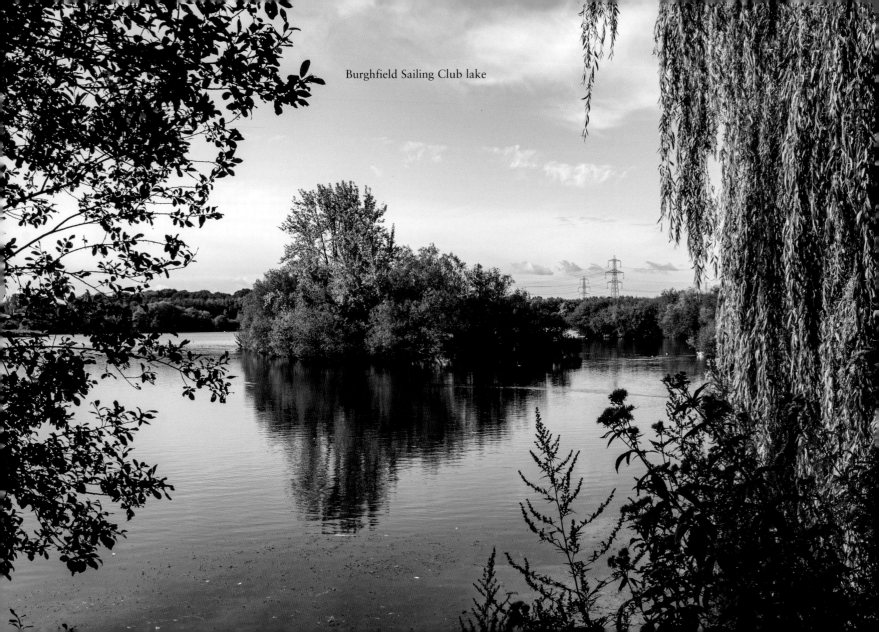

Burghfield Sailing Club lake

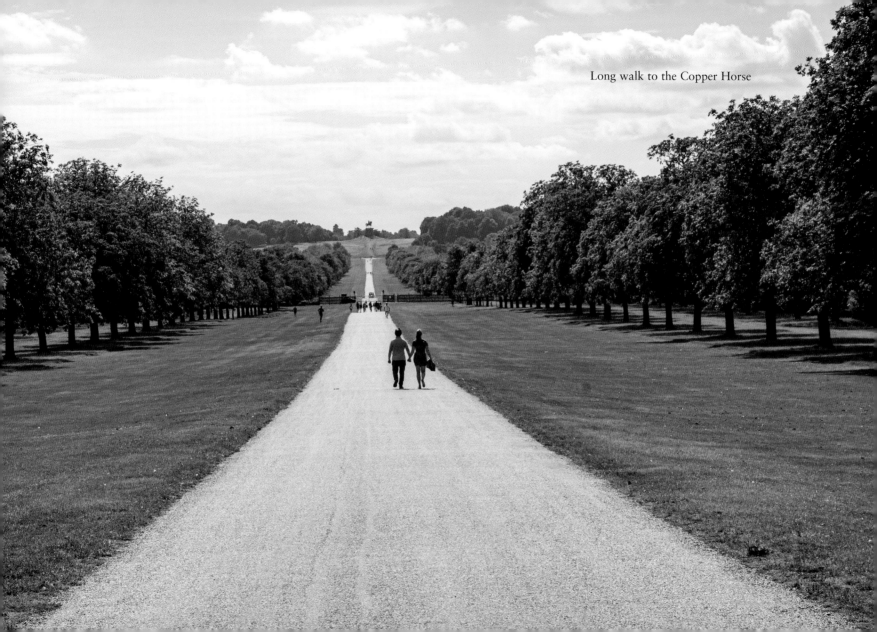

Long walk to the Copper Horse

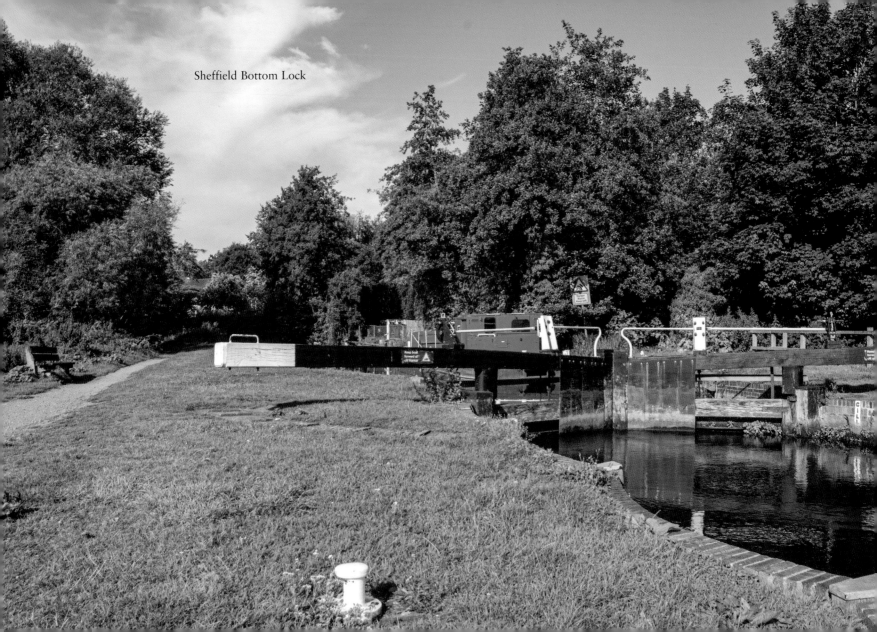

Sheffield Bottom Lock

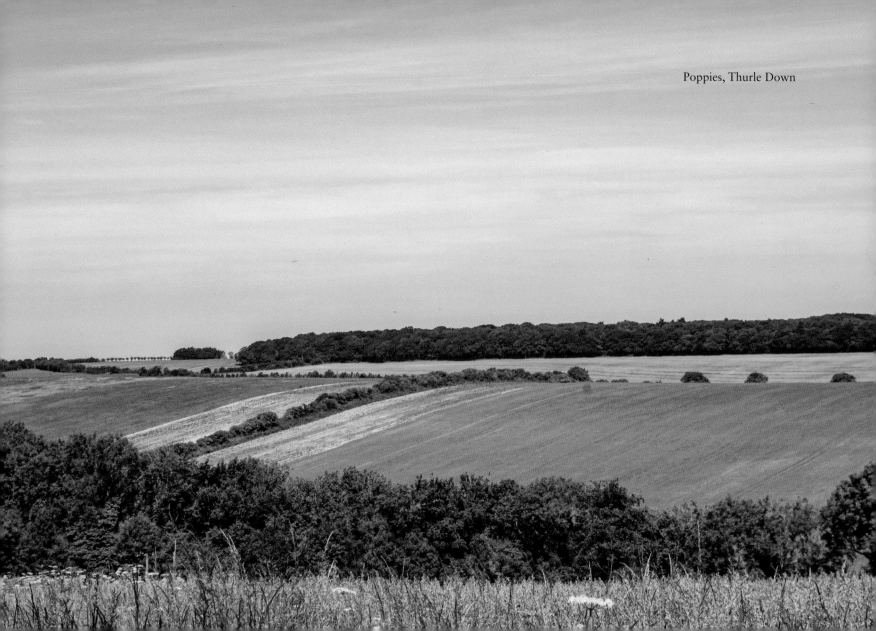

Poppies, Thurle Down

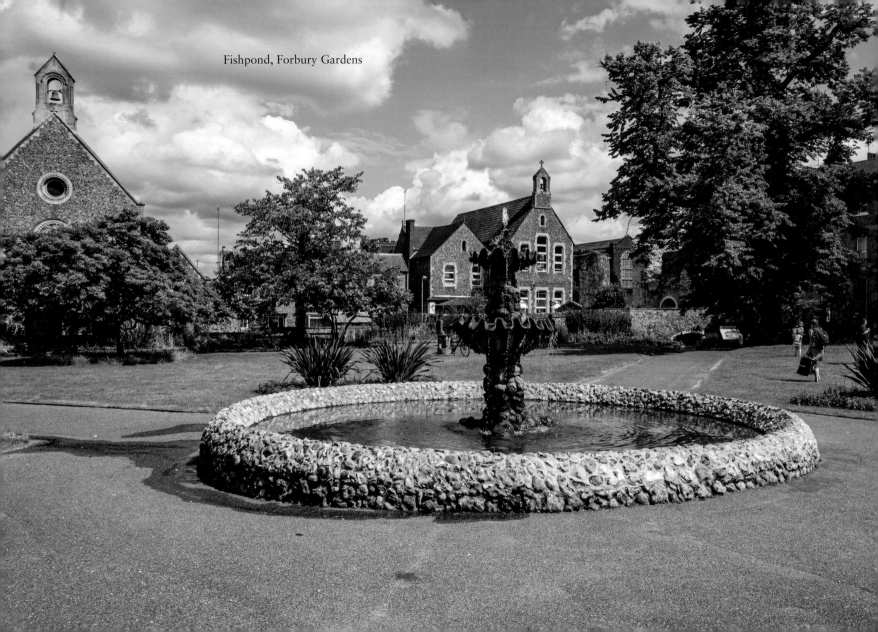

Fishpond, Forbury Gardens

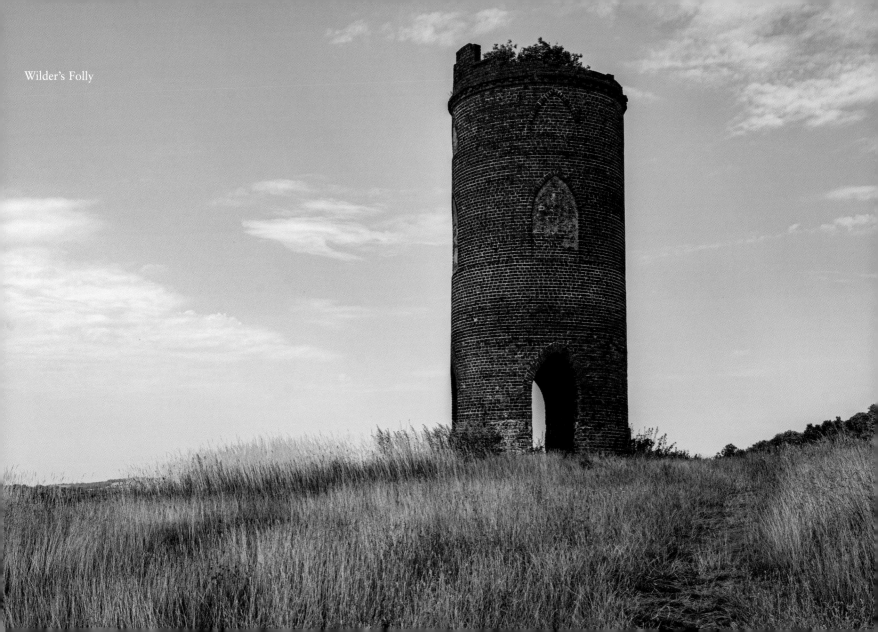

Wilder's Folly

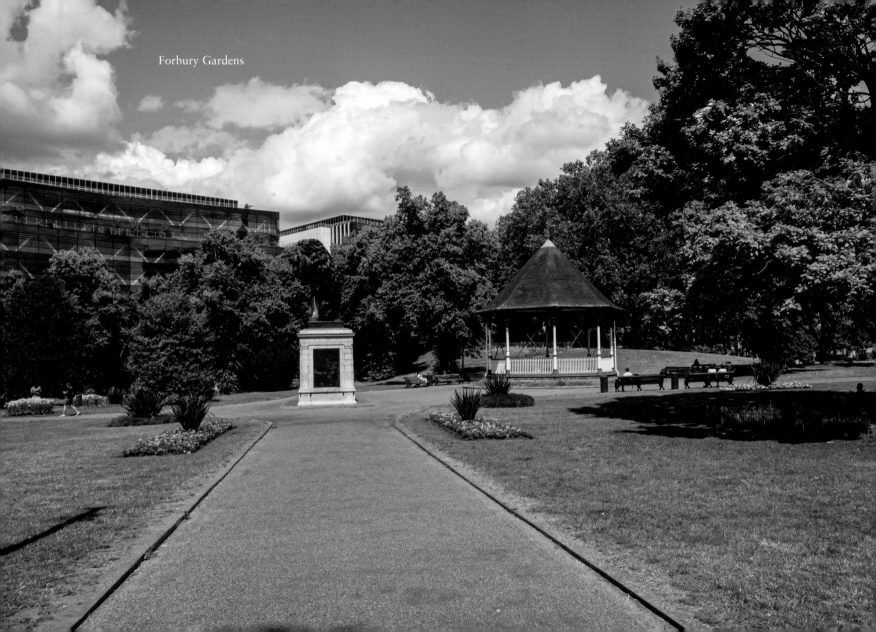

Forbury Gardens

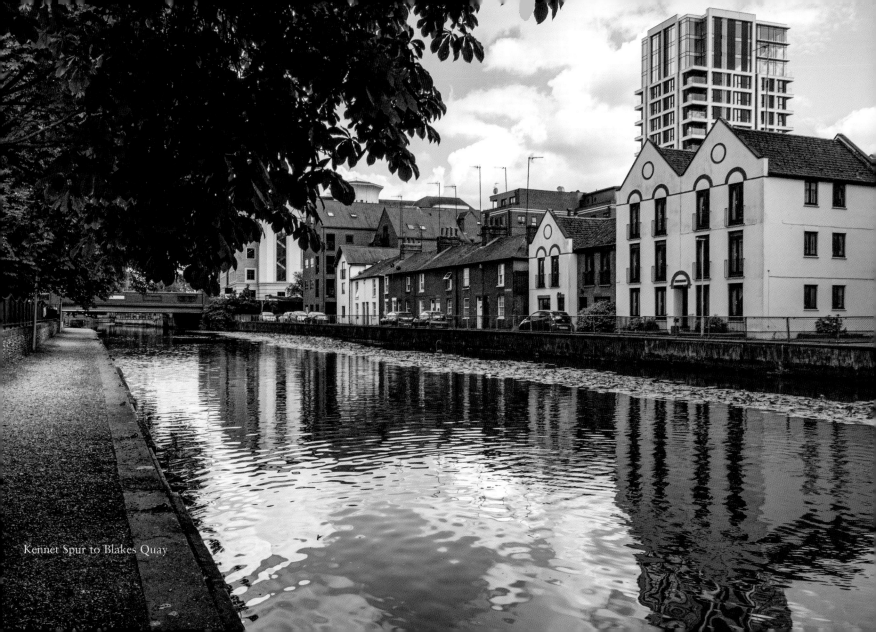

Kennet Spur to Blakes Quay

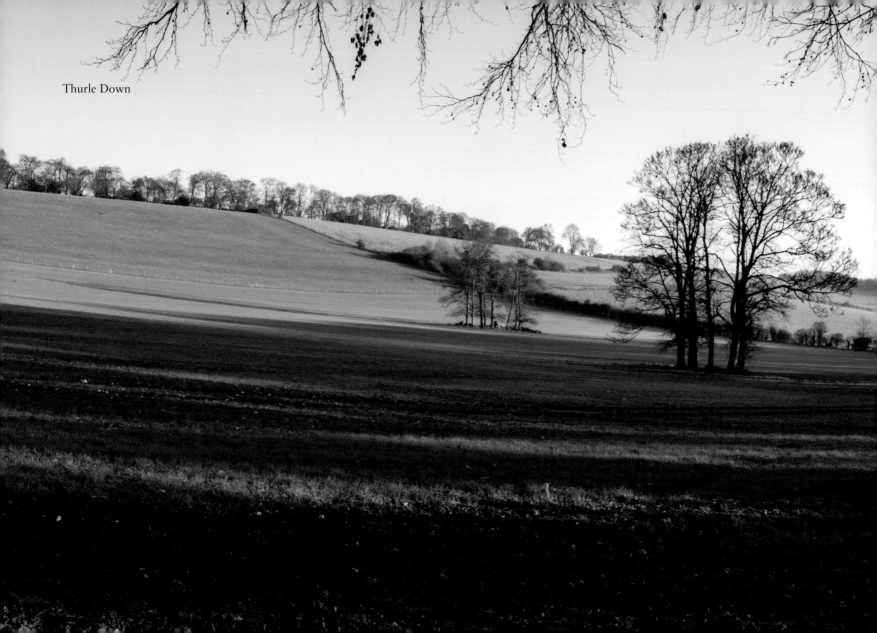

Thurle Down

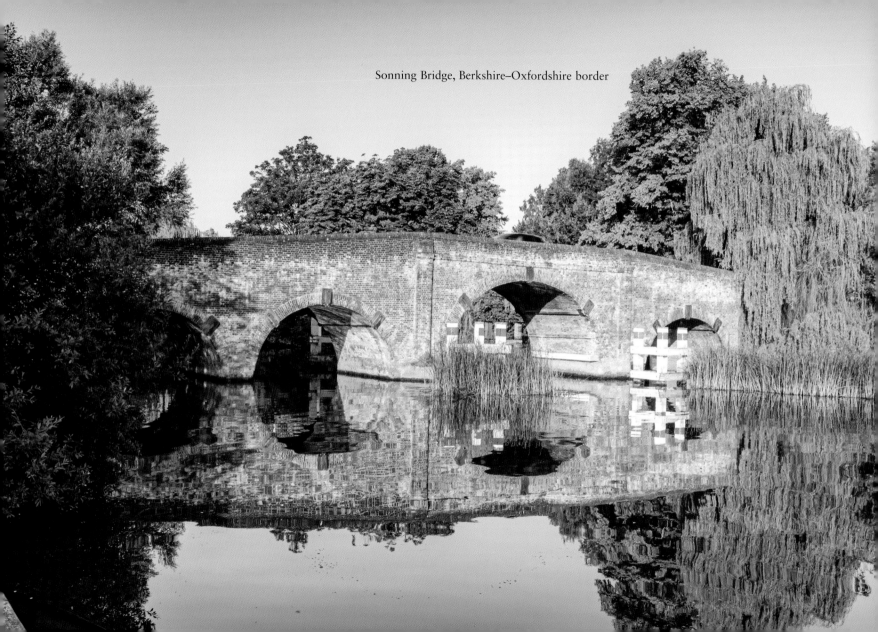
Sonning Bridge, Berkshire–Oxfordshire border

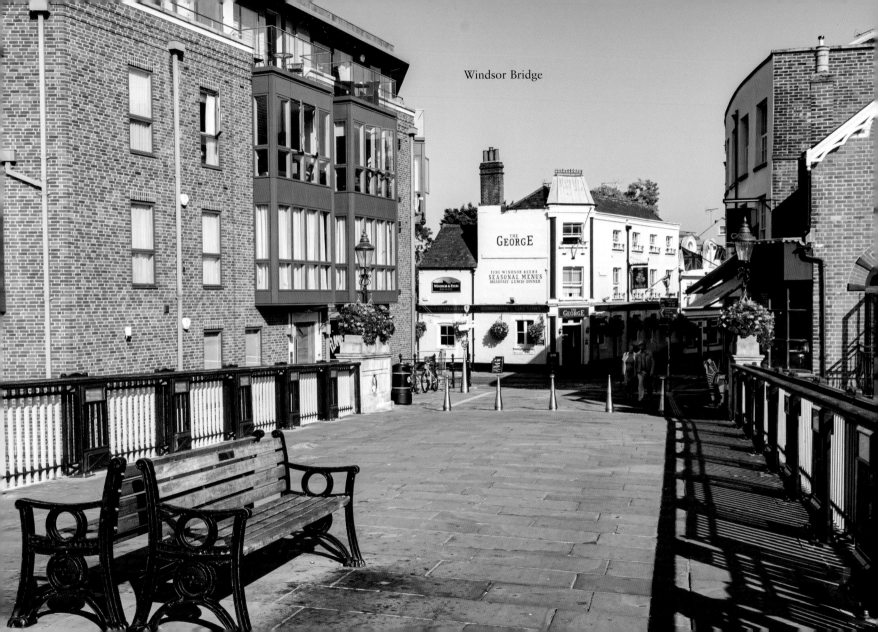

Windsor Bridge

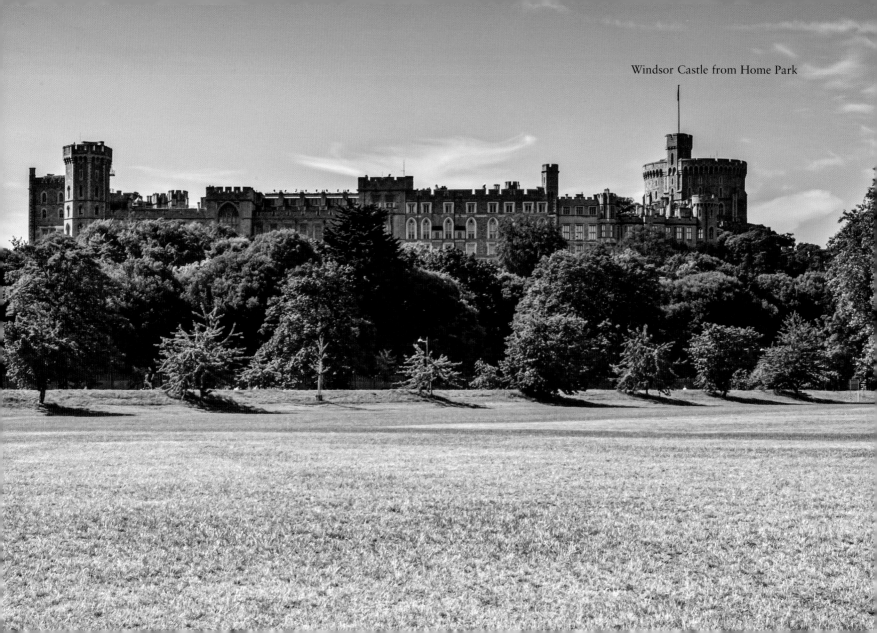

Windsor Castle from Home Park

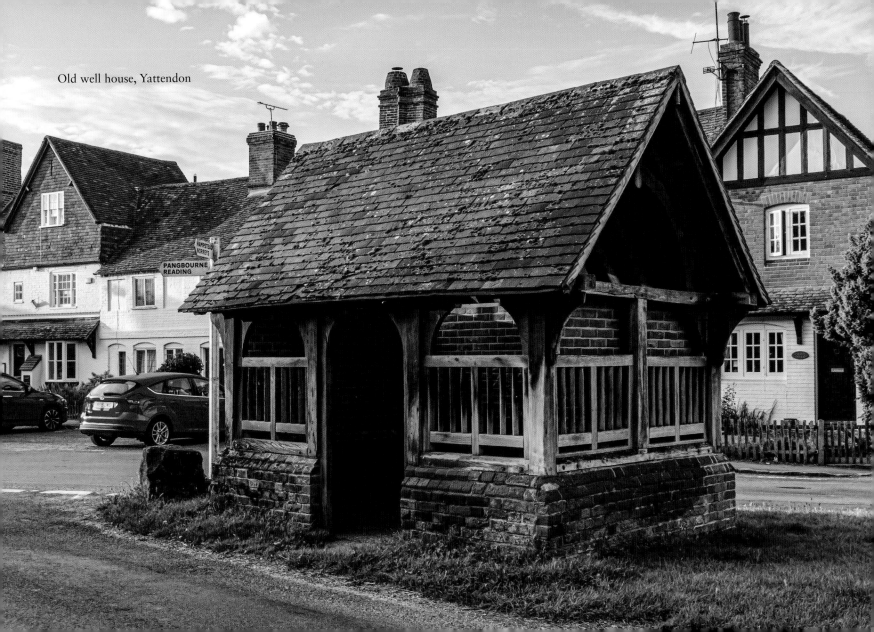

Old well house, Yattendon

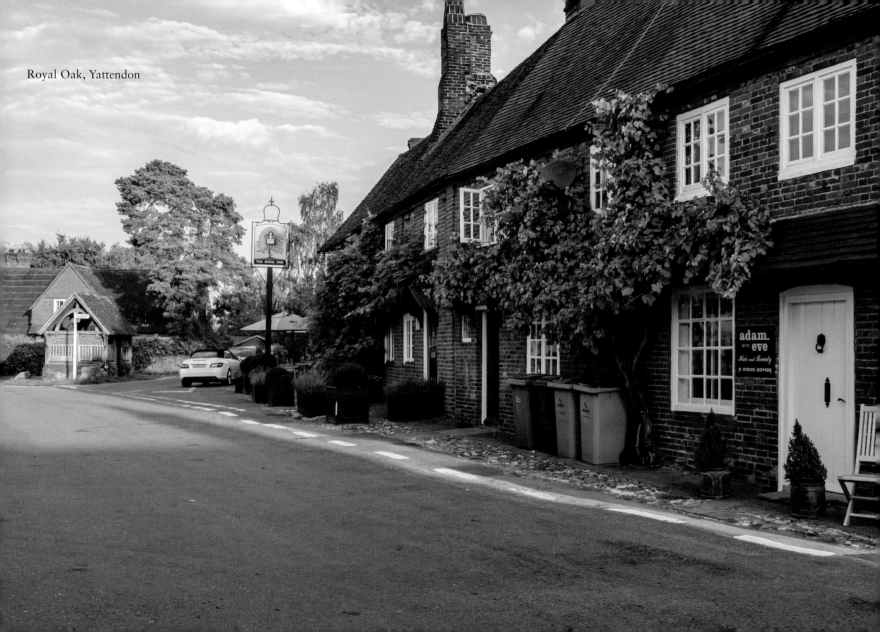

Royal Oak, Yattendon

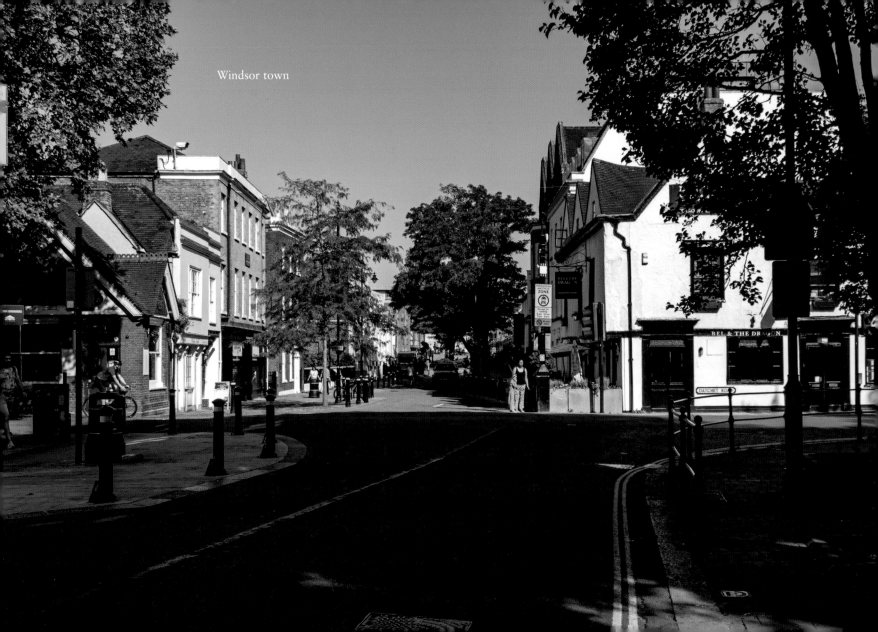

Windsor town

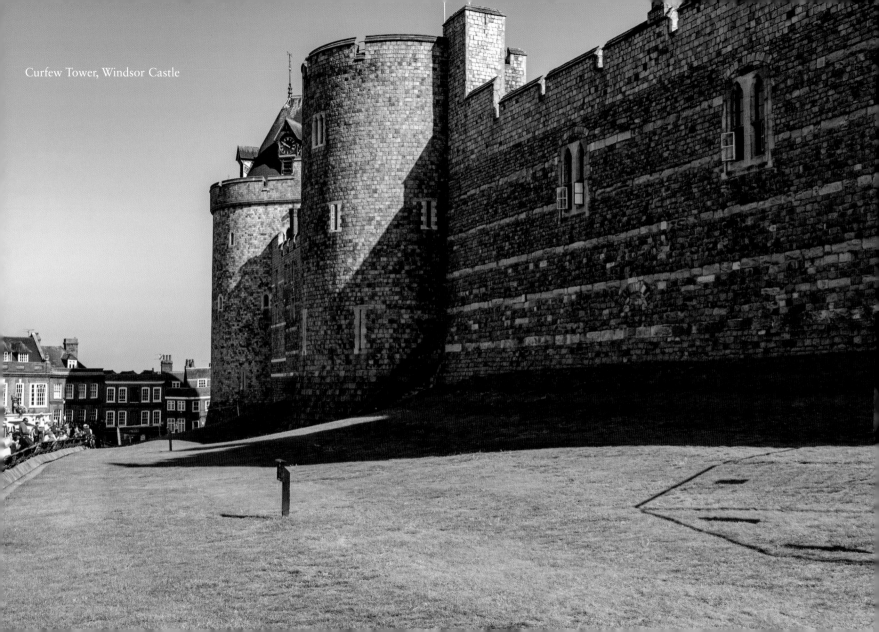

Curfew Tower, Windsor Castle

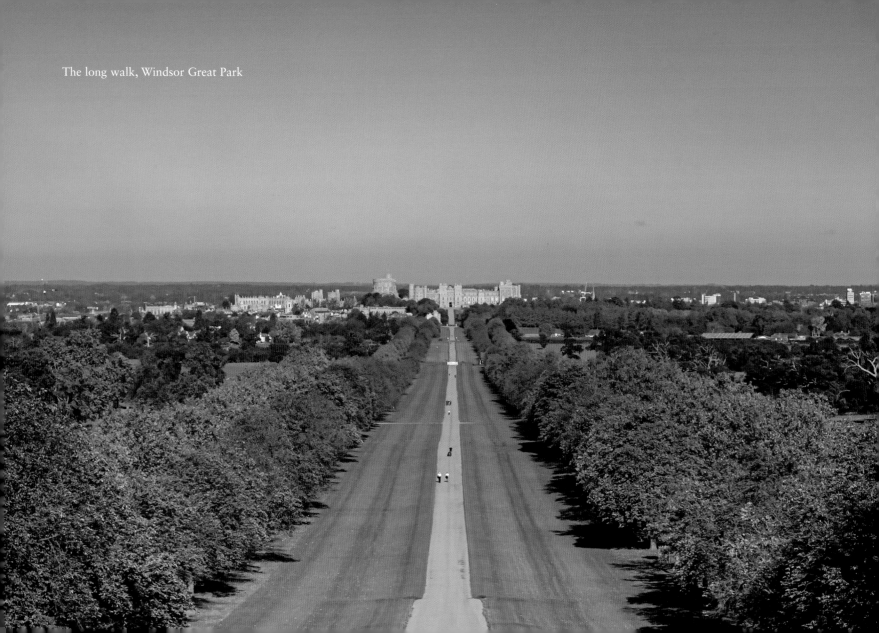

The long walk, Windsor Great Park